The Intelligent Eye

Learning to Think by Looking at Art

The Getty Education Institute for the the Arts

Occasional Paper Series

■

The Role of Imagery in Learning

Harry S. Broudy

Thoughts on Art Education

Rudolf Arnheim

Art Education and Human Development

Howard Gardner

The Intelligent Eye: Learning to Think by Looking at Art

David N. Perkins

The Intelligent Eye

Learning to Think by Looking at Art

DAVID N. PERKINS
Harvard Project Zero
Harvard Graduate School of Education

Occasional Paper 4

The J. Paul Getty Trust
Los Angeles

© 1994 J. Paul Getty Trust.
All rights reserved.
Getty Publications
1200 Getty Center Drive, Suite 500
Los Angeles, California 90049-1682
www.getty.edu

Sixth printing 2003
Printed in the United States of America

Library of Congress Cataloging-in-Publications Data
Perkins, David N.
 The intelligent eye : learning to think by looking at art /
 David N. Perkins.
 p. cm. — (Occasional paper ; 4)
 Includes bibliographical references.
 ISBN 0-89236-274-X
 1. Visual perception. 2. Art appreciation. 3. Critical thinking.
 I. Title. II. Series: Occasional paper ; 4.
 N7430.5.P52 1994
 701'1.—dc20 94-30
 CIP

Excerpt on p. 30 from "The Hollow Men," in *Collected Poems 1909–1962*
by T. S. Eliot, reprinted by permission of the publisher.

"Musée des Beaux Arts," p. 59, from *Collected Poems* by W. H. Auden.
Copyright © 1940 and renewed 1968 by W. H. Auden. Reprinted by
permission of Random House, Inc.

Table of Contents

List of Illustrations

Note: All works chosen are monochrome in the original and usually black and white to ensure that the black and white photographs used here represent them well.

Foreword

The message of *The Intelligent Eye: Learning to Think by Looking at Art* is twofold. First, David Perkins explains why looking at art requires thinking. Works of art do not reveal all their secrets at first glance, as he demonstrates through "seeings," records of his perceptions of some of the works reproduced here. Second, he presents an argument for the value of looking at art as a means to cultivate thinking dispositions. Drawing on recent research in cognition, he explains why art is uniquely qualified to support commitments to habits of thinking that are not hasty, narrow, fuzzy, and sprawling.

Thoughtful, reflective looking at works of art counters these negative dispositions because art offers a sensory anchor for our thinking against which ideas can instantly be checked. Works of art call forth our personal involvement. They invite us back with their affective impact. Looking at art requires us to draw on various types of cognition and encourages us to make connections with many other domains of human experience.

The Intelligent Eye is a unique contribution to the literature of arts education. Grounded in the disciplined inquiry of artists, art critics, art historians, and aestheticians, most books on looking at art assume that readers will choose to spend time with art for the intrinsic pleasure of coming to know specific works of art as good friends. Such works have typically focused on helping readers understand why learning about the aesthetic dimensions of works of art is important to a well-rounded education.

While David Perkins cultivates deep friendships with works of art, he comes to the enterprise of arts education from a different starting point. His focus is in large part on the extrinsic benefits of learning to look at art. For many years, arguments about intrinsic and extrinsic benefits of arts education have been perceived in opposition—either art was to be taught for its own sake or as a means to ends outside itself. The best thinkers in the art education field, Elliot Eisner and Harry Broudy, for example, have long recognized that the benefits of art education are not *either/or*. A multifaceted, comprehensive, sequential art education helps students both to understand the aesthetic dimensions of works of art and to develop their minds.

Central to this volume is the explanation offered for the value of art education in cultivating thinking dispositions. David Perkins explains that thinking dispositions are more than skills or strategies. As he notes in the first chapter, "a disposition is a felt tendency, commitment, and

enthusiasm." Much thinking done under the guidance of our experiential intelligence is accomplished quickly, without focus or clarity. Most of the time such unreflective thinking serves us well; we get done what needs to be done, we function easily in daily life. Perkins argues that a different form of intelligence, the reflective intelligence, is necessary to direct and manage the tremendous resources of experiential intelligence. How can we effectively cultivate our disposition to use reflective intelligence? There are a number of ways but, as Perkins argues, the characteristics necessary to thoughtful looking at art also characterize reflective thinking.

Most people spend only seconds with any work of art. The first habit to cultivate is that of taking time to look, pausing for a moment and engaging the work of art, just as one should pause and take time to consider any intellectual problem. The second habit, making looking and thinking broad and adventurous, counters the tendency of experiential thought to pursue the same narrow paths. Fuzzy thinking can be countered by looking and thinking clearly and deeply. Sprawling habits of mind are countered by the cultivation of organized approaches to thinking and looking.

As David Perkins explains, works of art demand various kinds of cognition. Each work asks us to encounter it afresh, drawing on past experiences and many kinds of knowledge.

Some viewers dismiss certain works of art as having little to look at. Perkins argues that it is not the work of art but the viewer who is lacking. Knowledge of the historical, cultural, and social contexts within which works of art have been created will enrich our looking and our abilities to think about art. Harry Broudy in *The Role of Imagery in Learning* argues that the "imagic store," the images that we have looked at long and deep, adventurously but with some structure to guide our thought, is a source of knowledge that funds our thinking in other areas. Perkins argues that the habits of thought cultivated by careful looking at works of art are necessary to balance experiential intelligence with reflective intelligence.

But how do we get from looking and thinking about art to thinking in general? In the late nineteenth century arguments for picture study, verbal analysis of black-and-white or sepia reproductions of traditional masterpieces of painting, included the claim that the personal qualities of the greatest artists would somehow be transmitted to students viewing their works. Other picture study advocates claimed that writing about the moral messages of masterpieces would inculcate morality into students. Half a century later arguments began to surface for teaching art as creativity. If children learned to be creative with paste and paper and crayons in school, their creativity would transfer to help them become creative as

adults. However, recent research on transfer of learning by Perkins and others discredits such naive views.

Perkins does suggest two approaches to fostering transfer of learning: the "low road" of frequent practice in applying the learned skills in varied contexts and the "high road" of reflecting on the skills being learned and actively making connections between skills and contexts of knowledge. Not only can students apply parallel skills in looking at art and reflective thinking in general, but art can provide a strong base for developing transfer because of its motivating qualities and capacity to support connections with the world outside itself. Near the end of the book, Perkins suggests ways that teachers can develop units of instruction around an artwork to support transfer. Although this Occasional Paper is not meant as a curriculum or guide to instructional strategies, many teachers and school policy makers will find that it offers a theoretical base from which curriculum units and instructional strategies might be developed.

In addition to enlightening us, *The Intelligent Eye* also challenges us. Researchers in art education may want to use the lens of "thinking dispositions" to make a closer study of cross-disciplinary connections between art and other domains or to identify more clearly and specifically the dispositions of thinking at work within each of the four art disciplines. Perkins's work should challenge

others to extend his arguments on why the arts may be better at building thinking dispositions than other subjects.

The four thinking dispositions described by Perkins might provide a framework for inquiry into the effectiveness of art education programs, as well as for assessment of individual student's abilities and performances. How well is an art education program cultivating dispositions that guide intelligent looking? Does the program encourage students to make connections between dispositions for looking at art and dispositions for reflective thinking in general? Are students given opportunities to apply looking and thinking dispositions frequently and with various objects? How well do students apply these dispositions? Where do they need further instruction or practice?

Finally, *The Intelligent Eye* suggests arguments for the value of art education that can be presented to parents, school boards, legislators, and others who need to know more about why art should be a part of general education for all students.

David Perkins builds bridges; as with *The Intelligent Eye*, much of his work has connected the two cultures of the sciences and the arts. Educated as a mathematician at the Massachusetts Institute of Technology, David Perkins did his doctoral work in MIT's artificial intelligence lab, while at the same time, he studied psychology

with Paul Kolers. Kolers introduced him to Nelson Goodman, the distinguished philosopher who founded Project Zero at Harvard in 1966. When I first met David Perkins in the spring of 1977, he had been affiliated with this program of basic research on symbolic development and human symbolic processes for over a decade. He has served as director or codirector of Harvard Project Zero since 1971.

David Perkins has long been interested in the arts and cognition, in theories of arts education, in creativity and its expression in artistic process, in visual perception and how people respond to works of art. His earlier books include *The Arts and Cognition* (Johns Hopkins, 1977), coedited with Barbara Leondar, and *The Mind's Best Work* (Harvard, 1981). More recently, Perkins has turned his attention to issues of thinking. His research has examined everyday reasoning and schooling, a dispositional theory of thinking, and the problem of transfer of learning. He recently completed a book on how schools can move from training memory to educating thinkers, *Smart Schools: From Training Memories to Educating Minds* (Free Press, 1992).

One of the joys of working with David Perkins is that he embodies what he writes about. When you talk with Perkins and he says, "Wait a moment, let me think about that," he gives himself thinking time. The conversation pauses while he reflects on the point. Not only

does he give himself thinking time, but, as readers of this monograph will discover, his thinking is broad and adventurous, clear and deep, and well-organized.

David Perkins also demonstrates these dispositions when he looks at works of art. Goals of the discipline-based approach to art education espoused by the Getty Center for Education in the Arts include helping students understand and appreciate the arts. The Center seeks to enable schools to demonstrate the value of the arts and their unique contributions to human life, as well as to help the American public understand why the arts are a vital component of general education. In these pages, Perkins models the kind of thoughtful, reflective looking at art that all of us want for ourselves and our children. It is clear that the arts are not peripheral in his life. In these same pages, Perkins offers the reasoned arguments of a skilled cognitive researcher for the benefits of using art as a means of cultivating thinking dispositions.

This Occasional Paper has provided an opportunity for David Perkins to bring together his long-term interest in the arts and his recent work on thinking dispositions in a monograph for a general audience. The intent of the Occasional Paper series is, in the words of Leilani Lattin Duke, director of the Getty Center for Education in the Arts, "to present ideas that will illuminate and inform the theory and practice of

discipline-based art education." *The Intelligent Eye* by David N. Perkins is an important addition to this series. Like *Art Education and Human Development,* the Occasional Paper by Howard Gardner, this paper demonstrates the complementary nature of the work done for what Dennis Palmer Wolf calls artistry-based art education by Harvard's Project Zero and for discipline-based art education by the Getty Center.

Other authors in this series, Elliot W. Eisner, Harry S. Broudy, and Rudolf Arnheim, have argued eloquently for the importance of art and imagery in education. David Perkins extends the scope of the series with his sophisticated yet witty argument for the importance of art in fostering sound habits of thought.

There is much to reflect on in *The Intelligent Eye,* and I hope that other readers will share my delight in David Perkins's wisdom and wit. It is a pleasure to stroll across the intellectual bridges he builds—both for their own sake and for the vantage points they provide for pausing to think about the value of the arts in general education.

Mary Ann Stankiewicz
Program Officer
Getty Center for Education in the Arts

Acknowledgments

*T*he preparation of this book was supported by the Getty Center for Education in the Arts. Some of the ideas expressed here were developed with support from the MacArthur Foundation for research on the teaching of thinking and the Spencer Foundation for research on teaching for understanding. My wife Ann Perkins and my colleague Shari Tishman helped me to think out, try out, and critique the view of art and thinking discussed here. Diane Downs, administrative coordinator of the Cognitive Skills Group at Harvard Project Zero, provided crucial assistance in locating illustrations, obtaining permissions, and producing the document itself. Four reviewers for the Getty Trust as well as Shari Tishman provided unusually insightful counsel on ways to improve the first draft. I thank these institutions and individuals for their encouragement and help.

Art and the Art of Intelligence

Beauty is truth, truth beauty,—that is all
Ye know on earth, and all ye need to know.
> —John Keats, "Ode on a Grecian Urn"

Oh, right. One of those irritating exaggerations that only poets can get away with. But Keats had a point. We human beings do invest a lot in visual expression.

Millennia ago, between dodging predators' teeth and claws, the people at Lascaux took the trouble to draw the animals of the day on their cavern walls. Now the young take similar liberties with the walls of subway stations. Those walls also hold examples of a slightly higher art and craft: advertisements subtly designed to send you to the tobacco store or the Chevrolet dealer in a buying mood. On a loftier plane, society builds temples to this penchant for visual form, calls them art museums, and invites the public to come and behold.

Investing time in making and enjoying visual expression is an entrenched human trait. Virtually all cultures display some form of art or visual ornamentation. From racing stripes on cars to the jazzy colors on my new pair of Nikes, human artifacts carry visual symbolism. The look of my Nikes is readier for speed than I am:

My feet can't keep up with my shoes! Nor is the visually energized object a modern invention. Consider, for instance, Figure 1, the carved wooden prow of a boat from the Tanimbar Islands, a bit west of New Guinea in Indonesia. This prow made the boat it adorned just as ready for travel as my Nikes. A rooster, symbol of aggression and energy, perches at the bottom while two fish swim between his legs. Part of his tail rises in splendid arabesques. From his neck emanates a swirling motif suggestive of the waves of the ocean. These lines from the Tanimbarese tell us a little more about the intent:[1]

Mami yaru o wean manut lamera o.
Nalili vulun masa wean lera fanin o.

Our boat o is like a rooster o.
It wears golden feathers like the rays of the sun o.

Cultures turn visual expression to diverse other ends—not only swift journeys but advertising or religion for instance—and some like our own give play to art entirely for art's sake. All in all, visual expression is a conspicuous part of any person's life and times.

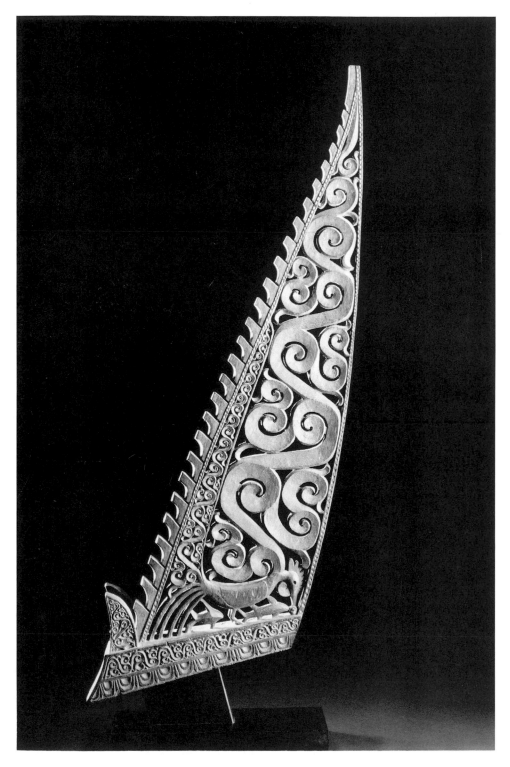

1. Prow board of a Tanimbarese sailing boat, date unknown. Carved wood, 5 ½ ft. high. The Barbier-Mueller Museum, Geneva, Switzerland. Photograph: P. A. Ferrazzini.

But for all that, in our habits of schooling, we are a long way from agreeing with Keats's urn that "Beauty is truth, truth beauty." As far as the usual curriculum goes, it's almost the opposite. If schools concern themselves with imparting truths, they certainly do little enough about beauty or other expressive dimensions of art past or present. The most that many students meet is brief craftlike experiences with paste pots and turkey-shaped stencils. Consider the dilemma of the principal or superintendent or policy maker, even one who has some affinity for art. "What am I to do?" he or she moans. "The parents are after me for higher math and reading scores. Where's the advocacy for art? It isn't there. No one cares."

People *should* care, of course. Looking within and across cultures, there is every reason to recognize the universal presence of visual expression and its powers of conveying information, provoking reflection, and stirring feelings. But telling people that they should care is a singularly ineffectual way of getting them to do so. So, the question arises: If we do not value visual expression enough to teach about it for its own sake, what else can be added to the argument?

Thinking through Looking

This short book for one thing. It has a double thesis: First of all, looking at art requires thinking—art must be "thought through." The prow of the Tanimbarese boat needs a long and thoughtful look, not just the passing glance, to begin to understand its message and savor its elegance.

Second, thoughtful looking at art has an instrumental value. It provides an excellent setting for the development of better thinking, for the cultivation of what might be called the art of intelligence. We can learn to use our minds better by thoughtful looking at the prow of a Tanimbarese boat—and many other things. "Thinking through looking" thus has a double meaning: The looking we do should be thought through, and thoughtful looking is a way to make thinking better.

Although this book concentrates on the audience role, art appreciation if you will, it's worth noting that thoughtful looking is just as important to the role of artist. After all, artists and artisans have to watch what they are doing to make a work come out as they want it to, or to discover how they want it to come out along the way. However, most people are much more likely to participate in art seriously as audience members rather than as artists or artisans. With the aim of serving the larger number, the focus here falls squarely on the audience role. A thoughtful approach to looking at art will vastly enrich people's experience of and understanding of art.

Now what is this about improving thinking? The notion that students need to think better has something of a following. Over the past twenty years, improving students' thinking has become an enthusiasm among educators and parents

alike—and for good reason, since testing programs, such as the National Assessment of Educational Progress, have shown that students commonly do not think very well with what they learn.[2] But how does art connect with this agenda? In short form, the argument runs as follows.

In routine situations, most people behave intuitively in remarkably intelligent ways. They cope well because they have learned their way around these situations, much as you learn your way around an unfamiliar town. Unfortunately, more novel and subtle circumstances often reveal the limits of our ordinary savvy. Everyday thinking in novel and subtle circumstances tends to be hasty, somewhat stereotyped, fuzzy in its details, and rather disorganized. To think better, people need to develop general commitments and strategies toward giving thinking more time and thinking in more broad and adventurous, clear and organized ways.

How can this be done? Typical approaches to developing thinking focus on cultivating thinking strategies, stepwise procedures for thinking better. The problem is, learners often find such strategies artificial and unappealing. Helpful as they may be in a technical way, they fail to capture enthusiasm and commitment.

Enter this book. Here it's suggested that looking at art provides a context especially well suited for cultivating thinking *dispositions*. A disposition is a felt tendency, commitment, and enthusiasm. Dispositions more than strategies (although not to the exclusion of strategies) arguably are the key to helping learners mobilize their mental powers.[3]

Art assists in a natural way. Looking at art invites, rewards, and encourages a thoughtful disposition, because works of art demand thoughtful attention to discover what they have to show and say. Also, works of art connect to social, personal, and other dimensions of life with strong affective overtones. So, better than most other situations, looking at art can build some very basic thinking dispositions.

Why Art and Not Auto Mechanics?

The focus on art here may seem idiosyncratic. Any subject matter has its intellectual demands. Why single out art? Why not auto mechanics. Or quantum mechanics?

There is insight in this objection. Good thinking dispositions certainly can be cultivated in the context of auto mechanics or quantum mechanics. Good thinking dispositions can thrive in any subject matter at any level. Moreover, in my view, some attention to thinking in general and the thinking required by different disciplines should be a standard part of education in all subject matters at all levels.[4] This granted, some subjects lend themselves more so than others to fostering better thinking disposi-

tions. For various reasons, art is an especially supportive context.

Here are some of the features of art that make it so. I mention them briefly here, taking up each at more length in the last chapter.

Sensory anchoring. It's helpful to have a physical object to focus on as you think and talk and learn. This comes naturally with art, which can be present either in the original or in reproduction, as in, for instance, a picture of the prow of a Tanimbarese boat.

Instant access. Along the same lines, the presence of the work permits checking any point of argument or seeking a new idea by looking, or looking closer, or looking from another angle. Look back at the prow. What do you see now?

Personal engagement. Works of art are made to draw and hold attention. This helps to sustain prolonged reflection around them. You can spend quite a while amidst the visual currents of that prow.

Dispositional atmosphere. As emphasized earlier, the aim here is to cultivate thinking dispositions—broad attitudes, tendencies, and habits of thinking. Art commonly brings with it an atmosphere of heightened affect synergistic with the building of dispositions. "Our boat o is like a rooster o. / It wears golden feathers like the rays of the sun o."

Wide-spectrum cognition. Although we tend to think of art as primarily a visual phenom-enon, looking at art thoughtfully recruits many kinds and styles of cognition—visual processing, analytical thinking, posing questions, testing hypotheses, verbal reasoning, and more. What might the fish under the rooster stand for? Could they be sharks?

Multiconnectedness. Art typically allows and encourages rich connection-making—with social themes, philosophical conundrums, features of formal structure, personal anxieties and insights, and historical patterns. For instance, we could understand the prow better through connecting it with the Tanimbarese culture.

Perhaps this brief list reveals something of why art is special. It is not so often the case that we can learn in the presence of compelling objects that engage our senses, allow for many kinds of cognition, connect to many facets of life, sustain our attention, and so on. Art is an opportunity. Let us not miss it.

Beyond "Look and See"

The connection between art and thinking may seem surprising. Too often, our encounters with art fall prey to a "look and see" mindset. We look. We see right away what there is to see, or believe we do. We like it or we do not. And that is all there is to it. But looking at art in ways that make sense of it calls for much more than that. Philip Yenawine, former director of education

at New York's Museum of Modern Art, puts it this way:

> ... *art is not supposed to be just beautiful, appropriate for a setting, or easy. Its most satisfying function is that it allows us to exercise our minds. An artwork will establish certain boundaries by its subject matter, style, materials, and techniques. It then lets us observe and analyze these givens by probing and musing. By finding its ambiguities, we can proceed in a game of speculation and interpretation.*[5]

The why and how of this view surfaces in the following chapters. With the image of the Tanimbarese prow to set us on our way, we journey through mingling currents of art and intelligence. Far from a scholarly treatise, the chapters to come offer a kind of practical philosophy of cultivating thoughtfulness through looking at art. I hope that people in general and school people in particular—administrators, teachers, and students—can gain from this inquiry into the better use of the eye and the mind.

The Intelligent Eye

The Barber's Question

I grew up in a small town in Maine, a nice place with nice people. A number of years ago, I had a program of research on visual perception. I remember a visit back home where I went to one of the local barbers. He asked me, "So what are you doing?"

"Well," I said, "one thing I'm doing is that I'm trying to understand visual perception—how people see."

He was puzzled. "How people see," he said. "That's interesting. I always figured you just open your eyes and see."

The barber had a point. His reaction highlights one of the most fundamental characteristics of perception. We just see. By and large, we do not have to reason out conclusions about the visible world. The velvet chair is there, in the right hand corner of the room, beside the Tiffany lamp, which is on the table. We see it all there. Period.

The barber's question honors the immediacy of perception. Yet it's worth being careful here. Just because perception usually works fluently, this does not mean that it is a simple process. Fluent on the outside can be dazzlingly complex on the inside. Hand calculators give us instant answers to mathematical problems like

$1.057 \times \$33,280$ by running a maze of complex calculations.

Because perception is fluent on the outside, the barber wonders whether there is anything to understand. The barber probably has in mind what might be called the camera model of perception. Seeing is something like exposing a photographic film. Your eyes look out upon the world; the light shines through the lenses of your eyes onto your retinas, which take a picture. That's perception.

What the camera model misses is the interpretive character of perception. A photographic film only captures the array of colors point by point. But when we look at the velvet chair in the corner of the room, we do not see a sprawl of colors. We see a dazzling spectrum of meanings. Here are some of them:

Shapes	Chair shapes and lamp shapes, for instance.
Solids	The chair and lamp have volume.
Backs	We can even imagine what the further sides look like.
Proportions	The back of the chair so high in comparison with the seat, the lamp shade so wide in comparison with the base.

Positions	The chair and lamp there, five feet ahead of you, the lamp on the table to the right of the chair.
Materials	The chair obviously velvet, the Tiffany lamp shade a mosaic of glass, a metal base.
Styles	The chair new, modern, the lamp not just any lamp but a Tiffany lamp from the turn of the century.
Economics	The chair expensive, the lamp a very valuable antique, or perhaps a reproduction.
Functions	The chair for sitting, the lamp for light, the table to hold the lamp.
Weight	A small not-so-heavy chair as chairs go. A heavy lamp with that metal base.

We look. And we see meaning upon meaning, all more or less immediately accessible. We do not have to stop to puzzle over shape, position, material, function, weight, or any of these features. They enter consciousness as soon as we turn our attention to them.

The Hungry Eye

The eye hungers to make sense of what lies before it. In most circumstances, we do not notice this quick eagerness to sort things out. We simply think of ourselves as seeing what's there. But artists have learned to capitalize on the hunger of the eye. They have learned to con-

struct provocative works that show how far the eye will reach in its quest for meaning.

Consider, for instance, the quirky pen drawing by Swiss artist Paul Klee in Figure 2 (see page 10). *Mask the title at the bottom with your hand.* Ask yourself for a quick intuitive response to these questions.

1. What is the sex of the human figure?
2. What is the age of the human figure?
3. What is the object at the top of the picture?
4. How bright is the day?
5. How warm is the day?

You could answer all these questions fairly quickly and intuitively. Most likely, you said that the figure was female, around twenty or thirty, the object above was the sun, on a fairly bright day, maybe with some clouds, and warm not cold. And I did not even tell you the title of the picture (you can look now).

It's worth pondering how easily we read these meanings from the picture, considering how oddly and sparsely Klee represents them on the page. The woman is about as far from photographic as one can get, a construction of two dozen or so quick lines, only a few of which mark the figure as female. The sun above does not have the conventional radial lines we expect in a drawing but lines that shoot out at a tangent to the circle. Yet we confidently read it as the sun. The dense parallel horizontal lines that

make up the background texture of the drawing do not emanate from the sun. Yet they powerfully signal brightness and heat. At the same time, through their subtle variations, they suggest the ground the woman stands on, perhaps a sea in the background, and a sky above that.

How can Klee communicate so much with so little? Only because the eye is hungry, eager to digest the mere data of light, ready to interpolate, extrapolate, conjecture.

Reasonable without Reasoning

Our reaction to Klee's drawing shows us the intelligence of the eye, the sensitive and emphatically conceptual character of perception that Rudolf Arnheim celebrates in his *Visual Thinking* and Elliot Eisner in his writings on education.[6] In dealing with data and reaching interpretations, the eye and the mind are usually reasonable. That is, perception reaches reasonable conclusions. Consider again the sun in Klee's drawing. Given the circular shape, its position, and the lines emanating from it, the sun is a sensible reading. To be sure, the lines are tangents rather than radii, not what we would expect and not physically accurate as far as light rays go. Still, all things considered, it's a reasonable conclusion.

But notice that there is little or no reasoning involved. We look at the picture for a few seconds. And we see the object at the top as a sun. We do not list and ponder the evidence. Whatever listing and pondering of evidence is needed

happens in some efficient microcircuitry of the mind with little conscious worry. To sum it up, one could say that perception is reasonable without reasoning. Perception reaches reasonable conclusions based on evidence, but without the extended process of deliberation implied by the word *reasoning*.

In case we suspect that capitalizing upon the reasonable character of vision is a matter for European sophisticates such as Paul Klee, let us take a look at another image that in its own way is just as abstract. Figure 3 is an example of a paper cut, a well-established Chinese folk art. This kind of round emblem, called a *tuan-hua*, often ornaments the ceiling above the bed of a newly married couple. The creatures shown, a dragon and a snake, possibly represent the years of the zodiac of the couple.[7]

Notice how confusing the eye might find this. Everything—flowers, vines, dragon, snake, border—is the same color. Contour lines are interrupted by other contour lines, as when the body of the snake crosses itself. Yet the artisan has handled the scales on the dragon and the snake and the general layout of the figure to give us the cues we need. When we gaze at this paper cut, we see not a tangle of paper, but a coherent image of two wonderfully sinuous and dynamic creatures against a background of flowers and vines.

None of this means that the eye is always right. The eye can easily be wrong, as optical

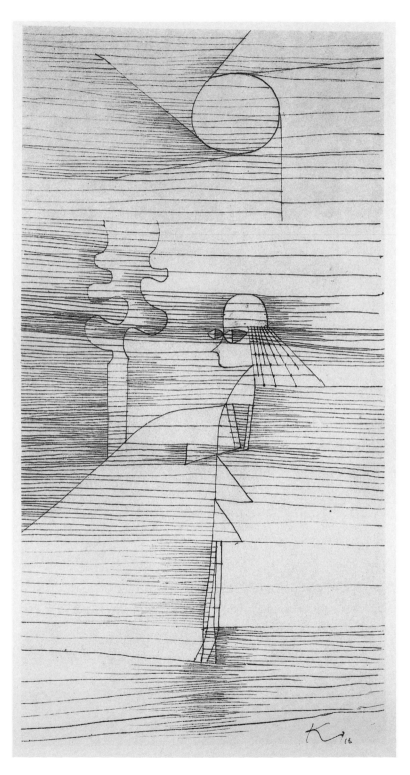

2. Paul Klee, *Mädchen unter der Sonne* (Girl Beneath the Sun), 1929.
Pen and ink, 12 × 6 in. © 1993 ARS, New York/VG Bild-Kunst, Bonn.

illusions show. In later chapters, we will deal quite directly with some of the shortcomings of the eye's reasonableness and what to do about them. But the point that the eye can be wrong should not put us off from the notion that the eye is reasonable. After all, full throttle conscious extended reasoning often commits errors. Ratiocinators can overlook a critical objection or miss a logical connection, and so can the eye, however reasonable.

The notion of reasonable without reasoning shows why it makes sense to speak of the intelligent eye. The eye and the mind interpret, interpolate, extrapolate to reach reasonable conclusions. Just what we would expect of intelligence. True, we do not find in perceptual functioning the extended reasoning process we often have in mind when we think of intelligence. But so what? Surely any process that reaches generally sound conclusions on the basis of sometimes slender evidence deserves credit for intelligence.

But what sort of intelligence are we dealing with here and what might we call it? Clues come from our response to Klee's drawing. Despite its schematic nature, we experience it in a certain way—as a young woman in the bright sun. Our eyes and minds reach a cascade of intuitive conclusions by some kind of rapid silent integration of evidence. This experiencing of the drawing depends, in turn, on prior experiences—about

the sun, women, weather, art itself, and many other things. To give a name to this quick, sensible, and sensitive work of the mind, we might speak of *experiential intelligence.*

Three Kinds of Intelligence

Intelligence is a long word and a large idea with a checkered history. What is intelligence? One point of departure is the psychologist's laboratory. The modern idea of intelligence was born when the French minister of public education in 1904 asked Alfred Binet, director of the psychology laboratory at the Sorbonne, to help find ways of detecting school children who might need special help. Binet developed what amounted to the first IQ test, although the actual term *Intelligence Quotient* and the calculation we now use came later. The great American psychologist and statistician Charles Spearman and others took over Binet's concept and extended it in a way Binet did not intend. They evolved a monolithic theory of intellect, treating IQ as a single essence underlying all intellectual functioning.[8] H. H. Goddard in 1920 offered an especially chilling expression of this view:

Stated in its boldest form, our thesis is that the chief determiner of human conduct is a unitary mental process which we call intelligence: that this process is conditioned by a nervous mechanism which is inborn: that the

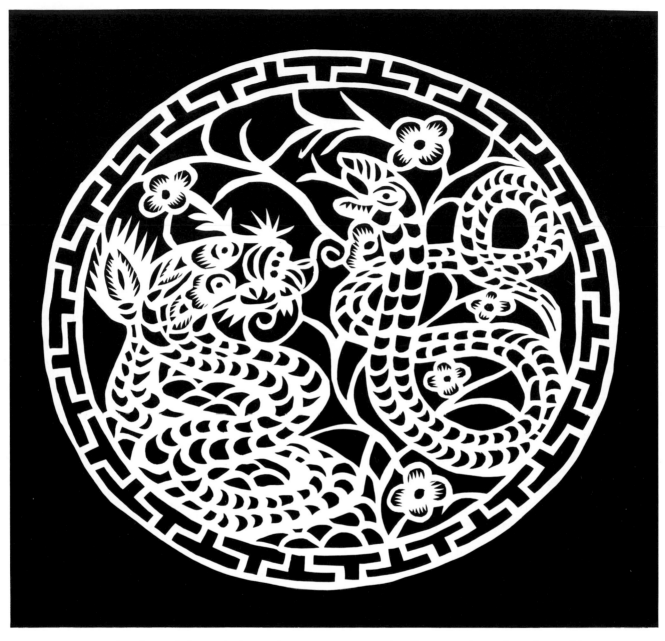

3. *Tuan-hua* (Round Flowers), date unknown. Paper cut, 9 in. diameter. Shaanxi Province, China.
From the collection of Nancy Z. Berliner.

degree of efficiency to be attained by that nervous mechanism and the consequent grade of intellectual or mental level for each individual is determined by the kind of chromosomes that come together with the union of the germ cells: that it is but little affected by any later influences except such serious accidents as may destroy part of the mechanism.[9]

In recent years, this classic view has been challenged in several fundamental ways. My colleague Howard Gardner as well as more traditional psychometricians such as John Horn have advanced the case for multiple intelligences, different kinds of intelligence that reside within the same human mind.[10] Yale psychologist Robert Sternberg has offered a "triarchic" theory of intelligence that honors creativity, the role of experience, and practical savvy, which the traditional view neglects.[11] Stephen Ceci and others have highlighted the importance of context-specific knowledge.[12]

The debate among such figures and between them and the IQ tradition throws into relief a fundamental question: What is our point of departure in thinking about intelligence? What, intuitively, is intelligence? A sensible approach to this question looks not to the psychological laboratory but to everyday experience and to the idea of *intelligent behavior*. The term *intelligent* is, after all, a part of our everyday language, with psychologists' technical notions far in the background. We speak of people behaving more or less intelligently. People who behave intelligently display wide knowledge, ponder decisions carefully, solve problems well, and so on.

In other words, we have strong intuitions about what constitutes intelligent behavior. Now, against this backdrop, what is intelligence itself? Intelligence is the set of underlying mechanisms. It is whatever mechanisms people have that help them to behave intelligently—skills, knowledge, concepts . . . or a superfast nervous system.

Surveying the many technical views of intelligence in contemporary psychology, one can identify three broad kinds of views about these mechanisms. All three have some basis in research and theory:

Neural intelligence: the contribution of the efficiency and precision of the nervous system to intelligent behavior. This view of intelligence is most prominent in classic "IQ" conceptions and their descendants, the views of Arthur Jensen for instance.[13] It also has a place in more pluralistic theories that posit multiple intelligences. Gardner, for instance, argues that the seven distinct intelligences he proposes have neurological bases.[14]

Experiential intelligence: the contribution of intuitively applied prior experience to intelligent functioning. In the last two decades,

psychologists working on areas from chess play[15] to handicapping at the racetrack[16] have particularly emphasized how much intelligent behavior in any area depends on a rich repertoire of experience that fairly automatically and spontaneously guides us.

Reflective intelligence: the contribution of mindful self-management and strategic deployment of one's intellectual resources to intelligent behavior. Over the past twenty years, many psychologists and educators have developed a special interest in mental self-management (often called "metacognition"), thinking strategies, and related aspects of the good use of one's mind. These include, for instance, Sternberg's view,[17] the theory of rationality advanced by Jonathan Baron,[18] and much of my own work in collaboration with several colleagues.[19]

This three-way distinction helps us to understand the debates that rage around the concept of intelligence. Neural theorists argue that in large part intelligence is inborn and unchanging. Advocates of experiential intelligence note that intelligent behavior grows with learning. But they warn against the notion that intelligence can be improved across the board. Rather, they emphasize the importance of context-specific development. Champions of reflective intelligence not only hold that we can learn to behave more intelligently but hold out for the possibility of general improvement through

strategies and attitudes that cut across many different areas of experience.

The clear resolution to such debates is that all these constituencies are wrong—and right. All want *their* kind of intelligence to account for the entirety of intelligent human behavior. But if psychology teaches us anything, it is that intelligent behavior is an enormously complex phenomenon, with ample room for contributions from different sides of the human organism. Inevitably, the efficiency and precision of neural functioning contributes to intelligent behavior; but so does prior experience in endless inarguable ways, and so does artful self-management.

A better cut comes from trying to see the three in relation to one another. Neural intelligence provides the substrate against which experiential intelligence and reflective intelligence play themselves out. All cognition occurs through the neural pathways of the brain. Particular talents arguably find their locus in neural structures better organized for various pursuits.

Of course, whatever a person's native endowment, later learning counts for a lot. Talents can go undeveloped when opportunities are lacking. And many people of no great talent learn to carry off anything from piano playing to political campaigning quite well. All because of learning. What, after all, dominates our moment-to-moment encounter with the world—the every-

day world of friends and hydrants, pets and cupcakes, jobs and lamp shades? There can be little doubt that experiential intelligence, true to its name, is the bread and butter of our ongoing experience. Most of the time we go along and get along, relying on our prior experience which lets us go along and get along quite well.

Experiential intelligence can do remarkable things. It can make sense of a sketchy drawing by Paul Klee. And we see the same rapid integration of information in many everyday insights. The other day, for example, I suddenly realized that I was angry without knowing it. I had had some frustrations. I was acting in a peeved way toward friends and colleagues. Then I stood back from myself. Immediately it all fell into place: "Of course. I'm angry." Once I turned my attention to my behavior, my mind quickly knit together the loose threads of experience from the past couple of hours and gave me the obvious interpretation. I did not have to think about it, but only to attend to it, just as you have to do little more than point your eyes at the corner of the living room or at the Paul Klee drawing to tap a stream of meaning.

But for all that, our experiential intelligence can easily shortchange us. What, for instance, if I had not turned my attention to my behavior? What about when people do not spend the time they need on a messy matter to let their experiential intelligence work for them? What about when your experiential intelligence takes you along routine paths worn by your previous experience, when you should exercise more imagination? In sum, powerful as it is, experiential intelligence by itself does not serve us nearly as well as it might, a matter we will explore more deeply in later chapters.

In particular, the intelligence of "the intelligent eye" lies in more than the reflexive work of eye and mind represented by experiential intelligence. The missing ingredient is reflective intelligence. In essence, reflective intelligence is a control system for experiential intelligence. By cultivating awareness of our own thinking, asking ourselves good questions, guiding ourselves with strategies, we steer our experiential intelligence in fruitful directions. This steering function is reflective intelligence.

Stereotypes about human intelligence plague our attitudes toward it. One mischief-making stereotype says that intelligence is only IQ and the neural machinery behind it. Another, equally troublesome in its own way, says that intelligence is pure reflection—all strategies and analyses and distanced perspectives. People feel uncomfortable with such a vision of intelligence, because it distorts the role of reflective intelligence. That role is not to bypass or substitute for experiential intelligence but to direct the subtle and powerful resources of experiential intelligence in better ways, to harness rather than bypass experience-based intuition.

The chapters to come show how experiential intelligence needs reflective intelligence to manage its powers for a fuller perception of art—and more generally for better thinking about anything. We will explore how reflective control over one's looking in particular and one's thinking in general can broaden and deepen the discoveries of the eye and the mind. However, before surveying what reflective intelligence can do for us, the first mission is to establish the need. Experiential intelligence alone will not serve. While experiential intelligence is the workhorse of human cognition, it can prove surprisingly weak in some circumstances. While experiential intelligence helps us to see what's there, often we see much less than there is to be seen.

The Challenge of the Invisible

Invisible Art

Art is invisible. At least to the quick takes of experiential intelligence. I'll prove it.

Consider, for instance, *Clothespin* by American sculptor Claes Oldenburg. During the early '70s, this artist constructed a number of giant objects such as baseball mitts, three-way plugs, and cigarette butts that shock us into reseeing these ordinary things by upsetting our expectations about scale. Clothespins were another of his subjects. One such *Clothespin* appears in Figure 4.

Look it over. It's a clothespin sure enough. Now let me add another observation, one you might make on your own but probably would not without a lot of exploration. The clothespin can be seen as a couple embracing and kissing. Look again. All of a sudden, you now see Oldenburg's sculpture in a new guise. The two halves of the giant clothespin seem like two figures face to face. The metal clip holding the halves together becomes the couple's intertwined arms. Is this just a fantasy interpretation, my whim? By no means. Oldenburg himself notes this interpretation of his *Clothespin*.[20]

While the eye is intelligent—hungry for reasonable meaning—this does not mean that the eye catches on to all that is there to be seen. As *Clothespin* shows, an important feature can easily elude the reflexive reading of experiential intelligence. We might say that often art is invisible, not the whole work of course, but significant aspects of the work. We simply do not see it. We see the physical thing, but not the art of it. Fortunately, art is not so stubbornly invisible as H. G. Wells's invisible man. By looking longer and in more refined, informed, and systematic ways, we can come to see what at first we missed. The eye is more intelligent with both experiential and reflective intelligence at work.

The Iceberg of the Invisible

One clothespin cannot hang this odd notion that art is invisible up to dry. Perhaps Oldenburg's sculpture is an odd case, a trick if you like. Other works of art reveal themselves readily, one might hope.

Unfortunately, Oldenburg's *Clothespin* is just the tip of the iceberg of invisible art. Considerable research on children viewing art teaches that viewers often do not see important aspects of works. Young and inexperienced viewers tend to focus on the content and find their reaction shaped in large part by it. If James and Alice like horses, and the painting shows horses, they like the painting. How the horses are rendered, with what style, dash, dynamism, playfulness, or

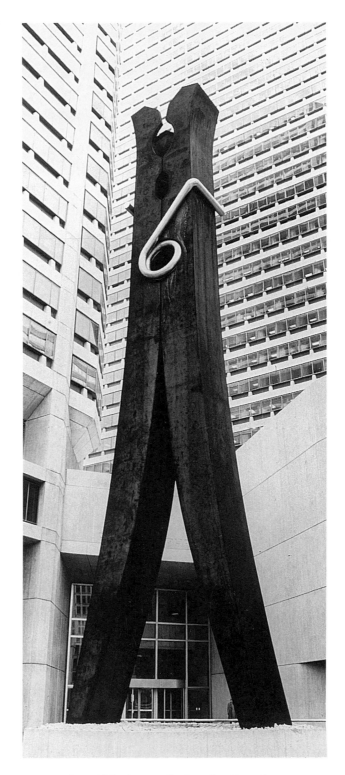

4. Claes Oldenburg, *Clothespin,* 1974. Cor-ten
and stainless steel, 45 ft. × 6 ft. 4 in. × 4 ft. Centre
Square, Philadelphia. Courtesy of the Pace Gallery.

decorum, does not matter much. As people grow older and gather more experience with art and other uses of image such as advertising, they gradually become more aware of the multiple dimensions art presents to the eye—stylistic differences, balance, mood, and so on.[21]

While children get better as part of normal learning and development, they do not entirely grow out of the invisibility problem. We adults can easily test for ourselves the invisibility of art on first glance by looking longer and harder, trying to make visible what at first is unseen. Consider, for instance, Figure 5, a woodcut by the German artist Käthe Kollwitz called *The Volunteers*. Unlike *Clothespin*, this is not a trick work. Yet it has its initial invisibilities. Gaze for a few seconds. Your first impressions probably go something like this:

■ The figures are volunteers for the war. The title says so.

■ They lean forward to the left and thrust upward, throwing themselves into the war.

■ The picture is dark, scary, anguished. Whatever it is, this is not your brave soldiers cheerfully marching forth to fight the good fight.

So far so good. But continue your scrutiny. Depending on how accustomed you are to this kind of looking, over a few minutes you might discover other things that you probably missed at first. For a little help in that direction, consider the following points:

■ The figure in the extreme upper left, is this a volunteer? Wait, look at the eyes, the nose. This is a death's head, not just one of the boys. Maybe you saw that at first, maybe not.

■ The volunteers project very different attitudes. The two rightmost figures seem awed, eager, frightened. The figure third from the right seems simply anguished. Is he really volunteering? The fourth from the right seems carried along by the others, eyes closed (in delusion, ecstasy, sleep?), oblivious to it all. The fifth perhaps is puzzled. The sixth is death. Of them all, only death's expression appears truly military, accented by his upraised fist, which holds one of the drumsticks. Death is beating the drum for this march.

■ "The Volunteers"—surely there is irony in this title. These men do not look like our stereotyped image of volunteers, courageously putting their lives on the line for higher ideals. They seem pulled along or thrust along by forces beyond them. Technically volunteers, they are draftees of circumstance.

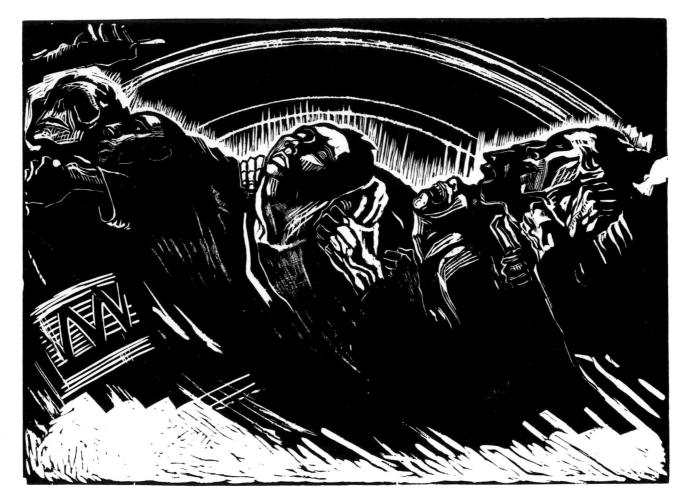

5. Käthe Kollwitz, *Die Freiwilligen* (The Volunteers), 1922–23. Woodcut, 14 ½ × 15 ½ in.
Courtesy of the Fogg Art Museum, Harvard University Art Museums, Gray Collection of Engravings Fund.

We can broaden our perception yet further by learning of others' perceptions of the same work. For instance, just what should we make of the different expressions on the faces of the volunteers. One possible reading appears above. But . . .

■ Commentator Martha Kearns sees them as all engaged in the same action: "The skeleton of Death, at extreme left, bangs a loud, relentless beat on a toy circus drum as five young men, screaming in patriotic frenzy, are pulled toward Death by the thunderous, dangerous drumbeat."[22]

■ Another interpreter, Elizabeth Prelinger, highlights the contrasts: "The jagged, deliberately disordered flicks and jabs at the bottom, in addition to the participants' range of expressions—from the beatific to the agonized—insist upon a highly ambiguous, even ironic interpretation of the scene, an impression that even the formally unifying "rainbow" at the top, usually a symbol of hope, cannot dispel."[23]

■ Mina C. Klein and H. Arthur Klein offer a very different interpretation of the sequence of figures, measuring by the meter-stick of mortality itself: "The two farthest right are still shouting patriotic slogans. Ahead of them is the tortured face (eyes hidden) of one who has just been wounded. Ahead of him, cen-

ter, is the unconscious form of one dying. And farthest left, is a glassy-eyed soldier, presumably already dead."[24]

Who is correct? There can be no final answer. But these contrasts remind us that puzzling over a work of art is a far cry from figuring out the one-and-only answer to a textbook algebra problem. Multiple interpretations are possible as we dig deeper and share readings with one another.

The moral: *The Volunteers* does not volunteer its subtleties instantly. We need to look persistently and intelligently. Most works are like this—largely invisible at first, they gradually reveal themselves to the patient eye and mind. Indeed, the invisibility of art is virtually a logical consequence of how art functions as a symbol system. Nelson Goodman in his *Languages of Art* emphasizes that works of art are "dense and replete"—the nuances along virtually any dimension count as significant parts of a work and influence the substance and tone of its statement.[25] With so much to see, how could we expect to see it easily?

Do We Murder to Dissect?

When we probe a work of art as we did with The Volunteers, what are we doing, and what ought we to think about what we are doing? Are we "analyzing?" If so, that might be something to worry about. Many people seem to find analysis

of works of art dry and unsatisfying. Some even hold that it undermines their overall experience of the work. The British poet Wordsworth advanced a stern indictment against analysis when he wrote:

Our meddling intellect
Misshapes the beauteous forms of things:—
We murder to dissect.

Enough of science and of art;
Close up these barren leaves.
Come forth, and bring with you a heart
That watches and receives. [26]

Are we falling into this trap? That depends on the kind of analysis at hand. The sort of looking we have just undertaken is not very dissective. It's more in the line of Wordsworth's "watching and receiving." We have not been figuring out the artist's technical tricks with composition or the control of line but have been digging deeper for features the artist plainly meant us to find and ponder—the death's head, the shades of awe and anguish on the faces of the volunteers. We have been looking for what *awaits* us in the work, what invites our attention and our responses.

Art historians and critics often emphasize another kind of looking. They seek out not just what awaits but what *hides,* peering backstage at the pulleys, trap doors, and rain machines that help to create the on-stage illusion. This endeavor typically analyzes how the work works, what strategies the artist used to build an impact. [27]

Such an analysis of *The Volunteers* would sound rather different from what we have done so far. It might say things like this:

All the figures stretch in the same direction, diagonally toward the upper left, combining into a single gesture. White streaks extend from the white boundary at the bottom to strengthen the gesture. Given this upward leftward motion, white arcs that occupy the upper center of the picture plane prevent the viewer's gaze from departing the picture altogether. They constrain the motion that otherwise would be unbalanced.

Does this analysis of what hides (rather than what awaits) spoil our experience of works of art? Like many people, I sometimes find such an analysis dry and would rather not bother with it. On the other hand, I often find it quite interesting, curious about how the artist pulled it off.

And frequently, I discover that looking for what's hidden enriches my experience of what awaits in the work. When I go back to look at the work in a less technical, more audiencelike way, I am more vividly aware of impactful features because of what I have seen backstage. I feel that way about the analysis of the white arcs along the top of *The Volunteers.* More aware of

them now that I realize their function, I look back at the woodcut in audience mode and find that they play a more active role in the overall expressiveness of the image. Maybe this is true for you as well. Why not look back and see.

To sum it all up, art is invisible in two important ways—what awaits and what hides. For the first, much of the art in the art awaits finding. It simply is not seen at first. To get the most out of the work, you need to find it. For the second, the artist's strategies are hidden, like backstage machinery. If you find that sort of thing interesting, you may want to search out what hides as well as what awaits. Moreover, discovering what hides may feed back to disclose more of what awaits, which you missed when you sought it directly.

What about Wordsworth's dictum that we murder to dissect? I think this overstates the problem. Regrettably, in some academic contexts, disclosing what's hidden—the technical underpinnings of a work—starts to displace disclosing what awaits—the more subtle expressive features of a work. But this is more kidnapping than murder. And if we can get what awaits us well in view, it does no harm and a certain kind of good to go after what's hidden as well.

The Intelligent Eye
Meets the Invisible World

The rest of the world is not so different from the world of art. Our experiential intelligence finds its main arena of application hour by hour, day by day, in the routine of our lives. There, as in art, things tend to be invisible that need to be seen. The eye served only by experiential intelligence is not intelligent enough.

Recall from the last chapter my example of recognizing that I was angry. I had to stop and stand back to discover that. As we sometimes fail to read our own moods, so may we fail to read others' moods. You should have walked on eggs today to keep a good relationship with your spouse, but you failed to read the signs. You should have bought milk, but you failed to notice you were running out. You should have checked the tires before your trip. Now your car's sluggish handling tells you that the right front tire is low.

Just as in the world of art, we can distinguish between what awaits and what hides. Matters like flat tires and irritated spouses await our discovery. On the other hand, the insides of watches, crankcases, walls, and so on, are deliberately hidden. There is no need to bother about them unless we have a technical interest. But of course, we may well have a technical interest. To disclose what awaits or what hides, in the everyday world as in the world of art, we need to get beyond the first impressions of our experiential intelligence. The previous chapter celebrated the remarkable powers of experiential intelligence to reach quick intuitive reasonable conclusions, integrating a variety of data. This chapter makes the other side of the case. Astute

as experiential intelligence is, the world offers up plenty that experiential intelligence misses, at least on first encounter.

Most of us suffer from an illusion that might be called the completeness of perception. We think that because we have pointed our eyes at something, we see what is there to be seen. But we are profoundly mistaken. We take in a scene holistically without realizing how partially we are seeing it, how schematic our perceptions generally are. For a truly intelligent eye, we need to get beyond the limits of experiential intelligence. To do that, we need to understand those limits better.

Knowledge Gaps and Intelligence Traps

Intelligent Up to a Point

Days after you move into a new house, you're still walking to a closet that isn't there. It was there in your old house. An acquaintance is late for a meeting and you're peeved. But you calm down when he arrives because he reminds you he said he might be a few minutes late. Filling a glass with orange juice, you're distracted and keep pouring until the glass overflows. You're startled by a small explosion when jump-starting your car; no one ever told you about the danger of setting off hydrogen gas leaking from the battery when you don't connect the cables in the right order.

Experiential intelligence carries us along pretty well most of the time. However, closets that are not there, unwarranted irritation, glasses overflowing, and other minor and sometimes major mishaps sound a warning. We need to understand better the limits of experiential intelligence and ask how we can push them back.

The limits seem to come in two flavors: knowledge gaps and intelligence traps. As to knowledge gaps, sometimes we do not see what we might simply because we lack relevant background knowledge. We may not know about hydrogen gas and jumper cables, for instance.

Or, in the case of art, we may not know the story behind what we are viewing or what to look for in the work. As to intelligence traps, even when we know all we need to, there are some bad habits of looking and thinking deeply rooted in the human organism. To mention one, we tend to look, think, and act hastily, even when we know better. Thus we keep going to the closet that isn't there. In the case of art, we may miss important features for lack of exploring long enough or in a sufficiently adventurous way.

Let us spend some time on knowledge gaps and then turn to intelligence traps.

Background Knowledge

Most of the images we encounter on television and in the pages of magazines come from our own culture and times. Once past the earlier years of life, we rarely have difficulty reading their messages. They assume a background knowledge we almost always have.

But this everyday experience cultivates a dangerous complacency. It obscures how much our seeing depends on what we know and take for granted. When we turn to works of art from other times or cultures, or from less familiar cultural enclaves within our own, we expect an easy entry for which we are ill-prepared. We often

blame the work for obscurity when it is we who are uninformed. Knowledge counts. It counts for a lot.

Figure 6, a drawing from the noted cartoonist and artist Saul Steinberg, is a case in point. Ponder this image for a moment. Recalling the distinction between what awaits and what hides, what awaits us here? How are we to read this work? What is happening? And what does the name coming in the window represent?

To decode Steinberg's statement, you need a crucial piece of information. Probably most readers have this information, but some might not. You need to know that there was a famous Italian opera composer by the name of Verdi. Now, you do not need to know much about Verdi. You may never have heard a single note he wrote nor know when he lived. You do not even need to know that he composed operas. But you must know that he was a composer.

This bit of knowledge is the keystone that holds in place the meaning of the entire image. What is coming in the window? It must be music, the sound of Verdi's music. What is going on in the man's mind? Reading the newspaper, the man has heard music coming in the window and turned toward the sound, wondering perhaps about its source. Does the man recognize the music? Probably, because it is a signature, the man hears it specifically as Verdi. How does the man experience the music? His expression is quite neutral. But the signature, elaborate and eloquent in its gesture, assures us that he perceives its richness. Does the man welcome and enjoy the music? He seems put off a bit. Notice how his face leans away from the signature even as it aggressively thrusts itself at him. Notice how much grander the music is than his simple line figure in a plain room reading a wordless newspaper. Indeed, the signature seems to bring more than just music into the room. It is like the romantic spirit of Verdi himself, palpably present in the flamboyant terminating strokes. The man seems taken aback: Verdi's music has so much more character than he.

These ruminations depend on innumerable bits of everyday knowledge—what a newspaper looks like, how to read the signature, what moods facial expressions signify, and so on. But they depend on one piece of knowledge that is a little less everyday, that many high schoolers, for example, might not know: Verdi is a composer. Steinberg's drawing is something of a borderline case, quite accessible to the well-educated in our culture. At the far extreme stand many works of art virtually opaque to the uninformed viewer because they depend on familiarity with medieval iconography, or Zen philosophy, or the pantheon of India, or some other, to us, arcane realm.

All this is obvious enough. Yet, accepting that background knowledge shapes perception as a philosophical or psychological point is one

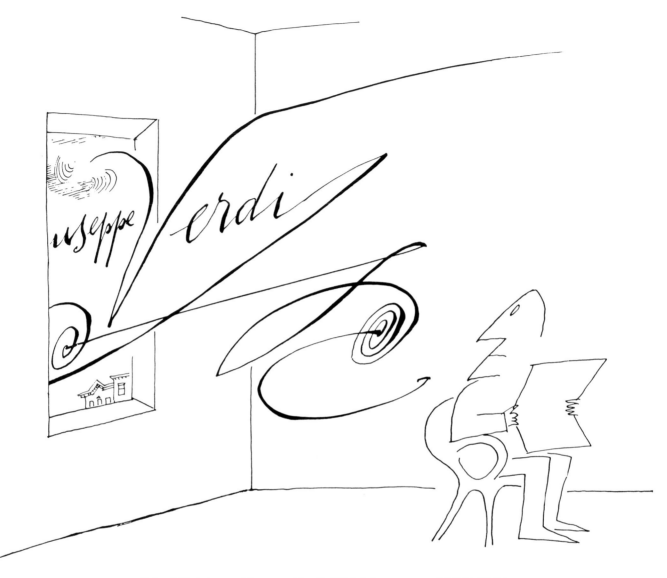

6. Saul Steinberg, *Giuseppe Verdi,* 1964. Ink on paper, 14 ¼ × 22 ¾ in.
© 1964, 1992, The New Yorker Magazine, Inc.

thing. Taking it to heart in your efforts to see the world is another.

Knowledge of Art

Whatever general knowledge of the world we bring to art, our special knowledge of the world of art itself is important. At its worst, art critical and art historical knowledge can sit in the mind's atticlike dusty memories from third-grade history—only providing the odd fact now and again. However, when we have and make lively use of such knowledge, it can color and deepen our experience of art immensely. It can help us find what awaits in art, and what hides as well.

A master of marshaling such knowledge is Kenneth Clark, who, in his *Looking at Pictures,* displays virtuosic powers of weaving into his moment-to-moment experience of works of art his deep knowledge of art history.[28] Consider, for instance, this passage about seventeenth-century Spanish painter Velásquez's renowned *Las Meniñas* (Ladies in Waiting), a gigantic but intimate painting of the pouty Infanta Doña Margarita and her attendants as they prepare her for a more formal portrait including the king and queen. Clark marvels over how real and candid the scene seems. But then he adds:

> *We do not have to look long before recognizing that the world of appearances has been politely put in its place. The canvas has been divided into quarters horizontally and sevenths vertically. The* meniñas *and the dwarfs form a triangle of which the base is one-seventh of the way up, and the apex is four-sevenths; and within the large triangle are three subsidiary ones, of which the little Infanta is the centre. But these and other devices were commonplaces of workshop tradition. Any Italian hack of the seventeenth century could have done the same, and the result would not have interested us. The extraordinary thing is that the calculations are subordinate to an absolute sense of truth. Nothing is emphasized, nothing forced. . . . Spanish pride? Well, we have only to imagine the* Meniñas *painted by Goya, who, heaven knows, was Spanish enough, to realize that Velásquez' reserve transcends nationality. His attitude of mind, scrupulous and detached, respecting our feelings and scorning our opinions, might have been encountered in the Greece of Sophocles or the China of Wang Wei.*[29]

Notice how easily Clark moves back and forth between the image and the context he can bring to it—the expected technique of journeyman painters, an imagined contrast with Goya, a snapshot of Velásquez's personality, and extra-artistic allusions to Greece and China, all are handy to his reach.

Such displays of erudition are both inspiring and daunting—inspiring because they show how

much your minutes in front of a work of art can be informed by what you know, and daunting because few know as much as Clark does. How can the much less knowledgeable expect to see as acutely?

Part of the answer is a call for patience. Clark's rich granary of knowledge is the harvest of decades of involvement in the arts. Another part, more immediately helpful, emphasizes that we do not need Clark's detailed and specialized knowledge to gain entry to many rewarding aspects of art. Indeed, some very general questions to ask yourself go a long way. Perhaps one of the most basic is, "What's going on here?"

What's going on, for instance, in Steinberg's *Giuseppe Verdi*? Once we ask the question, we have to follow through and think about it. What might the word coming in the window stand for? What does the man's reaction signify? Or what's going on in Käthe Kollwitz's *The Volunteers*? Once we ask the question, we have to look closely at the figures. Do they march forward with the same mindset? Who leads the parade? This question is such an obvious one that it may hardly seem worth mentioning. However, we all too easily respond to works of art as engaging images, without really asking ourselves just what they show.

Another question, one of my favorites, is, "What's surprising here?" Steinberg, for example, surprises us with the word coming in the window. He also surprises us with his mix of cal-

ligraphic and cartoon styles: The elaborately wrought signature is an anomaly in the Tinkertoy world of cartoons. We do well to remember that many artists are very much in the business of surprise of one kind or another. They aim to provoke, insult, aggravate, poke fun, shock, and turn things upside down, in small ways and big ones. In the end, we may not want to go along with a particular artist's outrage. But to refuse to do so at the beginning, before we have a chance to see where it might lead, is not to play the game at all.

What *not* to ask is as important as what to ask. In my view, a generally counterproductive question early on in viewing a work is "How good a work of art is this?" To be sure, we can hardly help having some sort of positive or negative reaction to a work. But this does not mean that we should rush to a firm judgment. Such judgments have too much finality; they tend to cut off our exploration of the work.

Apart from general questions, it's often helpful to know broadly what a group of artists thought they were up to. Take Pop Art, for instance—Andy Warhol's Campbell soup cans, Roy Lichtenstein's huge paintings in the style of romance and adventure comics. To treat such art seriously, it's helpful to know that these works aim in part to raise our awareness of our cultural icons, the symbol systems we take so much for granted. By enlargement, repetition, and other devices, works of this sort elevate our

awareness of a symbology submerged in the daily routine. Oldenburg does something similar with his giant *Clothespin,* as discussed in Chapter 2. When you know this, you know at least one way in which the work aims to engage your attention, reflection, and response.

One of the odd twists of knowing what artists thought they were up to is that artists were not necessarily up to what they thought they were— or at least said they were. For instance, Tom Wolfe, in his satirically critical examination of modern art, *The Painted Word,* pricks the notion that Pop Art expresses a purely intellectual concern with the semiotics of our culture. In characteristically flamboyant style, he writes:

> *Steinberg, Rubin, and Alloway had declared Pop Art kosher and quite okay to consume, because it was all "sign systems," not realism. But everyone else, from the collectors to the Culture buds, was* cheating! . . . *the culturati were secretly* enjoying the realism![30]

To know this (if you agree with it) is to recognize in Pop Art a kind of have-your-cake-and-eat-it-too quality, specifically have your realism and also wave it aside in the name of semiotics. Bearing this paradox in mind can enhance appreciation of such works all the more. If Kenneth Clark's example convinces us that knowledge of classical cultures can vastly inform the

seeing of classical art, we should not be surprised to find that insights into the fashionable philosophical hemlines of contemporary art can help us there as well.

This is no place for an exhaustive catalogue of general features to look for in art, much less an encyclopedia organized by era and genre. In the pages to come, as we get into more systematic looking at art, I will highlight a few more categories. Meanwhile, we should bear in mind that knowledge lies at the foundations of perception. The more knowledge we have to bring to bear, and the more actively we strive to marshall it, the more works of art will reveal themselves.

Four Intelligence Traps

Important as it is, knowledge is not enough. There is a mysterious and unsettling gap between knowing what we need to and getting done what we want to. As the folk saying avers, there are many slips twixt the cup and the lip. In a darker tone, T. S. Eliot captures something of the gap between the best of intentions and following through with these chilly lines from "The Hollow Men":

> *Between the idea*
> *And the reality*
> *Between the motion*
> *And the act*
> *Falls the Shadow*

So what sort of shadow falls between knowledge and action in our case? What keeps us from bringing to bear the knowledge we often have? One useful way to talk about the shortfalls of human thinking recognizes four unfortunate tendencies or "negative dispositions" in our intelligence.

In a sentence, human cognition is disposed to be *hasty, narrow, fuzzy,* and *sprawling.* This holds true of many everyday situations. And it holds true of looking at art as well. Let us ponder these shortfalls each in turn.

Hasty. Very often, people reach conclusions hastily, without the kind of deliberation the situation demands. For example, people often fall into the intelligence trap of making significant decisions impulsively, without working through the consequences. Regarding art, people often stand in front of a work, even one they like, for a mere half minute before moving on. A half minute of Steinberg or the last chapter's *The Volunteers* or any of the other images in this book yields a shallow experience.

Consider Steinberg's *Giuseppe Verdi* again. Here there is an obvious mistake to make—dismiss it as a cartoon. Of course, it is a cartoon of a sort. But it defies typical features of the genre. Cartoons are supposed to be schematic. They specialize in the hit and run: You look, you laugh, you turn the page. They are not designed to sustain prolonged regard. But Steinberg's

cartoon-or-whatever-it-is demands more of us. We can look and ponder and puzzle for a number of minutes.

Narrow. People tend to see and think in familiar categories and along well-worn tracks. To take decision making as an example again, people often fall into the trap of failing to look for creative options in a situation. They treat the decision as an inevitable choice between A and B, missing other possibilities that offer a better way out. Regarding art, people often look at works in narrow ways, not noticing expressive or symbolic aspects of works, and often dismiss works without exploring what they have to offer. For instance, cultural biases shape our expectations and lead us to perceive narrowly, even when we have in our mind's attic enough diverse cultural knowledge to examine a work from multiple cultural perspectives.

Consider Steinberg again. Viewing *Giuseppe Verdi* as a cartoon is not only hasty but narrow. As noted earlier, Steinberg even signals us that he is challenging the boundaries of the cartoon genre with the flamboyant Verdi signature, which falls outside its typical style.

Fuzzy. Much of human cognition is very rough and ready, relatively undiscriminating. Returning to decision making, people often fall into the trap of not sorting out their priorities clearly. They end up making decisions that do not reflect well their own highest priorities.

They react holistically rather than examining the tradeoffs. Concerning art, people often settle for holistic undiscriminating perceptions of works.

Remember, for example, how we had to look carefully at *The Volunteers* to gauge the different attitudes of each participant in the march. To miss this would be to miss much of the meaning of the work.

Sprawling. Considerable human thinking jumps from one thing to another haphazardly. Regarding decision making, people often fall into the trap of jumping around in thinking about an important decision rather than taking inventory of options and consequences. It's easy to lose sight of the forest for the trees. Regarding looking at art, people often glance here and there haphazardly at a work, making no effort to take inventory of what it has to offer. Of course, there is such a thing as being too systematic, but this hazard threatens far less often than the menace of utter meandering.

The 90% Solution

All this relates neatly to the notion of invisible art. It tells us something about where the invisibility lies. It's not the work that is invisible but our way of looking at it that fails to make it visible. Because of the four troublesome dispositions—hasty, narrow, fuzzy, and sprawling viewing—features of works stay invisible when they could well be seen.

Such shortfalls in perception point up a paradox in the notion of experiential intelligence. Chapter 1 emphasized what a powerful integrative and creative mechanism experiential intelligence was. But, here we find it subject to characteristic pitfalls. How can that be?

The answer comes down to three points:

1. The efficiency and effectiveness of experiential intelligence actually cause the troublesome dispositions toward hasty, narrow, fuzzy, and sprawling thinking.

2. This does not matter 90% of the time. Our hasty, narrow, fuzzy, and sprawling thinking is good enough, sometimes very good. To invest more time, exercise more imagination, reach for more precision, and try for more systematicity would be wasted energy.

3. The other 10% of the time, our hasty, narrow, fuzzy, and sprawling tendencies get us into trouble. This 10% contains some of our most important opportunities for richer experience, sounder decision making, and better cognition generally.

Let us revisit these points in more depth. First of all, why blame hasty, narrow, fuzzy, and sprawling thinking on experiential intelligence? Because experiential intelligence is streamlined for fast, efficient responding. It relies on rapid

automatic pattern recognition mechanisms to make sense of the inflow of information moment to moment. In other words, experiential intelligence is hasty by design; it aims at quick intuitive conclusions. As to narrowness, experiential intelligence lays its bets on the familiar, too. If it can project a familiar pattern onto a confusing array, it will do so without much worry about the validity of the familiar pattern, which after all is usually correct. This does not mean that experiential intelligence cannot function creatively: It can, if steered in that direction. But its bias is toward the familiar. Also, experiential intelligence works holistically, sorting large chunks of information into big patterns that often neglect nuances. Consequently, experiential intelligence tends to be fuzzy: casual about detail, clarity, and depth. Finally, a mechanism that cycles moment-to-moment, experiential intelligence displays little concern with systematic organization over time. It takes things as they come and reacts. In other words, experiential intelligence tends to sprawl.

All this is highly adaptive 90%, say, of the time. After all, most situations we encounter are familiar or untroublesome variations of the familiar. So experiential intelligence generally works well, often generates insights, and, when it produces errors, usually has a chance to correct them before much harm is done. If the underpinnings of our cognition lacked the rapid meaning-making mechanisms of perception, we would be much impoverished. The cost of those rapid meaning-making mechanisms is a disposition toward hasty, narrow, fuzzy, and sprawling perception and thinking that mostly serves us well enough but occasionally gets us into trouble.

So we should gratefully accept the 90% solution that experiential intelligence offers. But, to go with it, we need a 10% solution. We need ways of making the best use of our eyes and mind in situations where those four characteristic weaknesses cost us.

The 10% Solution

The rest of this book concerns the 10% solution, with emphasis on the case of looking at art. It explores ways of looking at art that make good use of the powers of experiential intelligence and take steps to dodge the characteristic pitfalls.

Looking at art is a good arena in which to exercise the 10% solution. Because art is what it is—artists reach out for the subtle, the complex, the powerful—most art sits in the 10% zone where the pitfalls are likely to matter. Kenneth Clark puts it this way:

> *Art is not a lollipop, or even a glass of küm-mel. . . . Looking at pictures requires active participation, and, in the early stages, a certain amount of discipline.*[31]

In contrast, such activities as commuting to work, dialing the phone, or cooking supper generally stay safely within the 90% zone.

Of course, there are many other areas of life that also fall within the 10% zone. The making of important decisions is one of them. Another is the learning of new ideas, in school or outside of school. Another is the handling of delicate personal relationships. Indeed, almost any occasion that involves some subtlety and novelty will have its 10% sprinkled in among the 90%. When you walk into a room full of strangers, 90% of your actions may reflect experiential intelligence about how to act in such a situation. But 10% of your effort may best involve conscious alertness to unexpected elements and conscious self-management to deal with the circumstances gracefully and effectively.

So what is this 10% solution? We have already met it: reflective intelligence. Remember, reflective intelligence is a control system for experiential intelligence. It's mental self-management, the use of self-monitoring and strategies to make the best of one's mental resources. It is the mindful strategic side of thinking. We should not view reflective intelligence as divorced from the powerful resources of experiential intelligence. On the contrary, the job of reflective intelligence is to manage the resources of experiential intelligence better, tapping its powers while avoiding those four intelligence traps of hasty, narrow, fuzzy, and sprawling thinking.

At the most general level, countering the dispositions toward hasty, narrow, fuzzy, and sprawling thinking requires corrective tendencies, dispositions that cut in the opposite direction. Instead of being hasty, we (10% of the time) need to give thinking time. Instead of being narrow, we need to make our thinking broad and adventurous. Instead of reasoning in fuzzy ways, we need to make our thinking clear and deep. Instead of sprawling all over the place as we puzzle about something, we need to make our thinking organized. All these are facets of mental self-management, of reflective intelligence.

These principles apply to looking at art as much as to anything else. One might sum it up this way:

Four Dispositions

Art in Particular	Thinking in General
1. Give looking time!	Give thinking time!
2. Make your looking broad and adventurous!	Make your thinking broad and adventurous!
3. Make your looking clear and deep!	Make your thinking clear and deep!
4. Make your looking organized!	Make your thinking organized!

Principles like these make for a distinctive approach to cultivating both thinking about art and the art of thinking. Most approaches to

sharpening people's thinking are strategy centered. They highlight techniques: moves you can make, steps you can follow, and six key questions to ask. Such techniques are certainly valuable. However, they often seem bloodless. They somehow miss the spirit of the enterprise. The present approach is dispositional rather than technical. It emphasizes the importance of very broad attitudes and commitments, the four listed above. It urges that particular moves to make, steps to follow, key questions to ask work best when they occur framed within broader dispositional commitments.[32]

The next four chapters take up the intelligence traps one by one. They show how we can become more intelligent lookers, not abandoning the reasonableness without reasoning of experiential intelligence, but guiding the work of experiential intelligence to avoid the intelligence traps and get much more out of works of art. Along with that come some general morals about the good use of the mind.

Making the most of this approach for the sake not just of appreciating art but of bettering thinking in general means paying heed to a fundamental challenge: transfer of learning. What we learn in one context we do not necessarily put to work in others. When we do make that connection, psychologists speak of "transfer"— something learned in one context that we "transfer" to another. In particular, good dispositions of looking at art, like those on the left side of the table above, do not necessarily and automatically transfer to better all-round thinking dispositions, the right side of the table.

Fortunately, there are some simple rules of thumb for attaining transfer. One recommends diverse practice. If the four dispositions see practice not only in the context of art but occasionally in other contexts as well, they are more likely to shape learners' thinking broadly. Another recommends reflective learning and the anticipation of possible applications. To the extent that learners are led to ponder explicitly the role of dispositions in looking and thinking, and to anticipate settings where these dispositions might prove helpful, transfer is more likely.

A section of Chapter 9 discusses transfer more fully. Meanwhile, let us take a reflective look at reflective looking at art.

Giving Looking Time

Audience Impressionism

Beware of impressionism. Stay away from it. I do not mean Monet's cathedrals and water lilies, Degas's dancers and horses, or Cassatt's brilliant interiors. Impressionism, as painters have practiced it, has given the world a mother lode of good-looking and expanded sensory horizons. More than that, impressionism has become an emblem of innovation, a symbol of challenging the status quo and reaching for new ways.

The impressionism of artists is fine. The bone to pick concerns the impressionism of audiences. Pause in any gallery and you will see this impressionism at work. Most blatant of all are the wall cruisers. They circle the walls, looking at each painting for a few seconds. Curiously, they often stand too close to see the works well, but somehow they seem satisfied.

Another side of audience impressionism less obvious but just as worrisome is grading. Many people approach works of art as though the main agenda were to give the works a quick grade— "that's an A, that's a D" or "that's really good; that's trash." Graders seem more concerned to grade a work than to understand it.

Almost everyone in a typical gallery seems to suffer from audience impressionism, on the evidence that they do not spend much time with works. Watch the people. How can they get the juice out in so short a period? They cannot. They can only catch a quick impression.

Of course, a certain measure of audience impressionism is fine in gallery or book browsing. To look at everything at length would be grindingly tedious. Quick evaluative impressions provide one basis for deciding what to look at longer. Unfortunately, most viewers do not get around to any of the looking longer.

Audience impressionism is a special case of that general problem with human cognition identified in the previous chapter: hastiness—a disposition to reach a quick resolution driven by the rapid intuitive mechanisms of experiential intelligence. Such an approach will not disclose what awaits in works of art, much less what hides. Striving toward a richer experience of art means working against this deep and natural impulse. It means calling reflective intelligence into play to cultivate a contrary disposition. It means slowing looking down.

What is it like to give looking time? Kenneth Clark in his *Looking at Pictures* sets out quite straightforwardly to record moments of perception in front of a work of art. While some passages seem more discursive, in others Clark

strives to capture the texture of experience. In the midst of discussing Titian's *The Entombment,* Clark captures how the painting provokes his attention this way:

> *But while my memory is still playing round these questions of pictorial means, my thoughts are deflected by the arm of Joseph of Arimathea, almost aggressively solid and alive. By the juxtaposition of this sunburnt arm with Christ's lunar body Titian takes me back from the contemplation of colour, shadow and shape and fixes my attention on the figures themselves. My eye passes to the head of the St. John at the summit of the pyramid, and as I pause for a second, enchanted by his romantic beauty, the thought crosses my mind that he is like a memory of Titian's youthful companion, the fabulous Giorgione, whose self-portrait has come down to us in various copies.*[33]

Clark's real-time reportage of the act of appreciation is worth emulating and extending. In this and the following chapters, we will make good use of "seeings" of works of art, stream-of-consciousness accounts of what one person might discern.

The Other *Starry Night*

Figure 7 offers a case in point. Speaking of background knowledge in art, a first glance at this image will reveal it to many as an old friend, Vincent van Gogh's famous *The Starry Night.* But this is something else. It is not a painting at all but a drawing, now regrettably destroyed but available in reproduction. While the painting enthralls us with its colors, even the black-and-white drawing projects much of the dynamism of the painting.

Here is one seeing of *The Starry Night.* Of course, the eye sees so much that the phrases that follow only sample bits of the experience. Read this record of perception, glancing back and forth at the drawing. Try to catch the spirit of giving looking time.

Time	Perceptions	Comments
1st min	Energy everywhere. The tree spiraling up into the sky. The swirling sky, like currents in a sea. The moon upper right, concentric lines around it, moonglow. A strange impossible moon, its crescent almost closed. The landscape swirls like the sky. A church, a steeple. The steeple reaches up like the tree.	*The eye and mind allowed to roam and do their work of discovery.* *Words mark and underscore perceptions.*
2nd min	Houses, a village. Fields, a farming community, people. Energy lines	*Letting questions about the work arise.*

7. Vincent van Gogh, *The Starry Night,* 1889. Pen and ink, 18 ¼ × 24 ¼ in. (destroyed).
Photograph: Netherlands Institute for Art History, The Hague.

Time	Perceptions	Comments
	everywhere. Is it the wind, a windy night? Is the flow in the sky the milky way? What spirit invests the picture? The energy flows everywhere, like a pulse, a bloodstream.	
3rd min	Circles in the sky echo one another, the moon's circle, the circles of the stars. No circles found below. What kind of a tree is that?—don't know. The land like a sea, in motion. The temperature? Warm, a summer's night, the stars blurred soft and brilliant. Van Gogh in ecstatic mood.	*The looking persists well beyond the typical period.*
4th min	The church again. Religious significance? Where do people fit in? The nestled village, engulfed in all this. All part of the flow. Smoke from the houses, swirling like the rest, joining the village to the sky.	*Questions and perceptions still emerge.*

Time	Perceptions	Comments
5th min	Horizontal motion, vertical motion, horizontal in the sky and horizon, vertical in the tree, the church, the smoke. The impossible moon. The fantastic landscape. The tree like a flame. Is it windy? Still? Is the swirl the wind or some natural energy?	*Reseeing some features.* *Questions continue to puzzle, even after considerable looking.*
6th min	Wind and flow of light and deep energy in nature all merged. Logic: It's not windy. The smoke from the houses goes straight up. Nature itself on the move.	*Key question answered. Common knowledge helps here as elsewhere.*
	Seeing nothing new. Nothing new. Look away.	*Looking away refreshes the eye.*
7th min	Look back. Sudden technical interest. The **S** motif, a graphic gesture, clear in the sky. And elsewhere. Follow a flow, all the way across the sky around the moon. The moon brings your eye	*Looking back yields new perceptions. Attention shifts to more technical interests, "what's hidden."*

Time	Perceptions	Comments
	back. You can't spin off into space, the moon stops you. The tree pulls your eye back.	
8th min	Look away again. Look back. Some of the circles have dots in the center, stars. Didn't see before. Smoke echoes steeple echoes tree, the vertical motif. The land dissolves into the sky through these conduits, becoming the sky.	*Looking away and back again, seeing and re-seeing.*
9th min	On the right, the land-scape flows left like rapids. Right to left motion on the ground, left to right in the sky. Brings the eye back around. Leftward flow on the ground stopped by tree, lifted up into the sky, brings the eye back around. The eye caught in the flow of the picture, like an eddy in a stream.	*Letting the work push your eye, following and noting the flow.*

The Rhythm of Vision

This log represents only one possible seeing of *The Starry Night*. We always have to remember how readily works of art lend themselves to multiple readings. Your eye may follow somewhat different paths of vision and meaning. Nonetheless, perhaps the log conveys something of the rhythm of vision, how experiential intelligence moves when given the time in which to move, how basic cultural and practical knowledge comes into play in recognizing villages and churches, in noticing clues like the vertical smoke. The log registers a flow of recognitions and realizations as the eye catches on to what awaits in the drawing. One insight follows another, sometimes logically, more often associatively.

The words and phrases in the log are partly a report but also tools of seeing. Describing what we see telegraphically in words, on paper, or by talking to ourselves, helps to heighten and stabilize perception.[34] So also do wordless actions that underscore perceptual experiences, for instance, imagining yourself underlining or circling important features.

Words and gestures help to take the pulse of perception's progress, letting you know when you are not seeing much new. Then looking away, letting the eye rest a moment, and looking back often bring fresh insights. Many insights come late, building on earlier ones.

What happens to experiential intelligence when we slow looking down? Are we pushing

experiential intelligence to one side and adopting some more analytical way of regarding art? Are we taking a cold shower in the technicalities, what the artist has hidden from us rather than what awaits our appreciation? No. We are buying time—time for experiential intelligence. By calming its impulsiveness, we can keep the intuitive engine of experiential intelligence producing insights for many minutes.

What accomplishes this work of calming and prolonging? Reflective intelligence, which by definition functions as a control system for experiential intelligence. In partnership, the two generate a response far richer than experiential intelligence alone can muster.

Slowing Looking Down

So what does one do to give looking time? Persistence and patience are the most important ingredients, the commitment to stick it out and see more than you otherwise would see. Beyond that, there is a certain craft as well.

Suppose you have selected a work you think might be worth looking at for a while. This could be for many reasons—perhaps you like it initially, someone has recommended it, you know it to be well regarded. When you are ready to give looking time, these rules of thumb may help:

- Position yourself. Beware of placing yourself too close. Find a good distance, where the work coalesces into a whole (but feel free to move in and out).

- Resolve to look for a good while, say three to five minutes at least. Your resolution will help you to stick with the work.

Then . . .

- Let your eyes work for you. Remember the hungry eye. Automatically, as you look, your experiential intelligence will seek meaning of many kinds.

- Let questions emerge. Don't feel that seeing consists entirely in reaching conclusions. Especially for something as complex as art often is, seeing puzzlements that may get resolved later is an important part of the experience.

- Let what you know inform your looking—what you know in general, about art in particular, and about the source culture and era of the work. Let your knowledge come forward to tune your vision, as Kenneth Clark does in the quote earlier.

- Tell yourself when you notice interesting features. Label them in words you say to yourself. Or imagine underlining them or drawing a circle around them on the work.

Or, as in our "seeings," take notes. Any of these actions heightens your awareness of what you are seeing.

As you look longer . . .

■ When the flow stops, look away for a few seconds, then look back. Looking away helps to refresh your eyes.

■ As you keep looking, you will not only discover new features but resee features you found before with more familiarity and fluency. Enjoy this part of the experience, too, as you get to know your way around the work.

Notice how nonspecific these principles are. They are truly rules of thumb. They do not define any lock-step process that constrains significantly the free play of experiential intelligence. They do little more than ensure fruitful persistence.

An Image for You: *The Descent from the Cross by Torchlight*

The Starry Night seems full of a pagan energy, a kind of pantheistic religious feeling. Figure 8 offers a very different expression of faith. Whatever your religious background, you probably have relevant cultural knowledge: You recognize an episode in the life and death of Christ. It is *Descent from the Cross by Torchlight*, an etching by the seventeenth-century Dutch master Rembrandt van Rijn. Rembrandt gives us a starkly human view of the aftermath of the crucifixion—Christ's lifeless and pitiful body taken down from the cross at night.

Spend some time with the image. Find your way into the nuances of this sensitive work. Mark your progress somehow as suggested above, by talking to yourself, imagining circling parts of the work, or even keeping a seeing log like that for *The Starry Night*.

The Art of Thinking

If giving looking time is important for art, giving thinking time is important in general. Thinking through opportunities and dilemmas, no less than looking at art, inherently calls for deliberation. As with giving looking time, we need to muster our reflective control of our thinking, giving thinking time to let our experiential intelligence do its intuitive connection making. A disposition to give thinking time is something to be sought and cherished.

Sayings and stories from around the world make this a point of folk wisdom. In English, we say that a stitch in time saves nine. When I was young, I wondered for a while, "nine what?" But eventually I figured out that it's nine stitches—invest one stitch now to save nine stitches later, a deal that would make Scrooge himself happy. In the same spirit, we say that haste makes waste.

8. Rembrandt van Rijn, *Descent from the Cross by Torchlight,* 1654. Etching, with drypoint, 8 ⅜ × 6 ½ in. Archer M. Huntington Gallery, The University of Texas at Austin, University Purchase, 1961. Photograph: George Holmes.

Other cultures have found ways to package the same wisdom. For instance, a tale is told in South Africa of a man who had worked for many months in the mines. He set off on the long walk home to see his family, carrying a load of iron on his back that he could sell in the neighborhood of his home for his family's benefit.

Along the way, the man fell into a deep hole in the ground. Although unharmed, he could not climb the steep sides of the hole. He called out and eventually drew people who lived nearby. They braided a rope from grasses and threw it to him. Carrying the sack of iron on his back, he tried to climb out. But the rope broke. The people repaired the rope, but again the rope broke. "Leave your sack behind," they said.

"I will not," the man said. "It is for my family."

So the people left him there, since it was almost dark, promising to return in the morning. All night the man thought about his dilemma between periods of restless sleep. He finally reasoned, "If I insist on carrying the sack, my family will have neither me nor my iron. If I leave the sack behind, at least they will have me." He reconciled himself to leaving the sack behind.[35]

The man's circumstances led him to give thinking time. With a little more thought yet, he might have found some even better resolutions of his dilemma, such as tieing the sack of iron to the rope and letting the people pull it up and then him. Time for thinking does not guarantee it will be well used, but without the time there hardly can be good thinking.

Taking this precept seriously means cultivating in ourselves an understanding of, commitment to, and habit of giving thinking time. "Cultivating" seems to be the right word here. The aim is not to master seventeen discrete skills or all the steps of an armamentarium of strategies. It is something broader, more attitudinal, more a matter of mindset than of any particular plan of action or trick of tactics.

How should we approach this endeavor? Any comprehensive curriculum is beyond the scope of this short book. However, one general guideline is to cultivate through culture: to create a culture—in the home, classroom, or wherever—that honors giving thinking time, establishes it as legitimate, avoids the rush to hasty resolutions, musters time for working things through, and allows for the revisiting and rethinking of things.[36] Of course, thinking things through should not proceed to the point of paralysis or of belaboring things that do not need to be belabored. But we want no more of sweeping complex matters under the rug of hasty resolutions. I speak of a culture because the term makes clear that doing any one single thing is not enough. Rather, what is needed is an attitude and commitment distributed across people and over time, and manifested in many large and small ways.

If creating a culture of giving thinking time offers a social approach to the challenge, what about an individual approach? From an individual perspective, giving thinking time is a matter of cultivating in oneself the right sort of attitude. One way to conceive such a process is as a kind of dialogue with oneself.

Let us imagine that in each of us there is a Dr. Watson and a Sherlock Holmes. Watson is curious although a bit naive about the ways of the mind. Holmes is confident in his convictions, and with good reason, although perhaps overenthusiastic about the glories of cerebration. Remembering that these are both characters on the stage of our inner minds, here is what such a dialogue might sound like.

Holmes: Watson, we really must acknowledge the talent of the human mind for the quick take. Most situations require no more. Looking for my tobacco pouch, I assuredly do not need to ponder and puzzle about what I am doing. Even though I exercise some flexibility—perhaps the pouch is under my violin or behind the divan—I cope with hardly a thought.

Watson: But tell me, Holmes, what puts you in such a philosophical frame of mind?

Holmes: Why, finding my tobacco pouch of course. Under the cushion in fact. It makes one ponder time itself, Watson. The time that real thinking takes, not that of the tobacco pouch variety.

Watson: I have seen you unravel some criminal conundrums with remarkable facility, Holmes. Time did not seem to be the critical ingredient.

Holmes: On occasion, perhaps. But you still do not know me, despite our adventures together. Finding a tobacco pouch is one thing, but untangling a mystery something else. Oh, Watson, we are all too subject to the illusion of closure, to having a satisfactory resolution when in fact we do not. We must give thinking time!

Watson: A wholesome motto to be sure.

Holmes: More than wholesome, Watson. Necessary. I venture that the greatest hazard we as sentient beings face is the illusion of adequate closure. We think we see at once what is there to be seen. But, Watson, we do not. The only escape from this illusion lies in looking further, to give thinking time to get beyond it.

Watson: Well, to be sure. Let us indeed give thinking time. But then *when?* When to give thinking time? Surely, Holmes, not *all* the time?

Holmes: I can always rely upon you to defend the pragmatic. As you say, not all the time. Not even most of the time. The quick work of the intuitive mind mostly serves us well, and we would be foolish indeed not to take advantage of it most of the time.

Watson: Then when would you make your exceptions and "give thinking time" as you put it?

Holmes: Ah. Most of all, when the stakes are high. I am hot on the trail, and some deliberate

thought may ascertain the identity of the culprit. Or let us suppose that I am a student preparing for an exam. Or I am pondering a career. Although, I assure you that in my case I am entirely happy with the career I have.

Or when I am puzzled. Puzzlement, there is a reliable signal for you, Watson. With your sterling quality of persistence, you will recognize that many people seem to allocate no more than five minutes to understanding anything. However, you, as well as I, know that insight often comes gradually through gnawing away at the bone.

Watson: Well, since you have the why and the how so clearly in view, you must complete your exposition by explaining the "how." How to give thinking time?

Holmes: We have to take ourselves in hand, my dear Watson. It is all too easy to just go on to the next thing. To create time in the middle of a conversation, I might say "let me think a minute." And then indeed think a minute. To seduce myself into giving thinking time, I might set myself down with a pipe. I might disappear into my room. You know my ways. And you see the principle. I give thinking time by creating intervals of time that I can then fill up with my thinking. Such a simple thing, but powerful, Watson, powerful.

Making Looking Broad and Adventurous

Thinking by Numbers

Painting by numbers is no one's vision of high art. You get a kit with a canvas partitioned into tiny odd-shaped numbered regions. When you hold the canvas well away from your eyes, you can even make out what cow or sailboat it will soon represent. The numbers match a couple of dozen tiny capsules of paint. All you have to do is transfer the paint of appropriate number (brush provided, of course) to the regions. With patience, a painting emerges. Someone else's painting, of course. You have simply been the technician.

Painting by numbers is painting of a sort, but not the sort we usually admire. Curiously, a good deal of human activity, including human thinking, is just as by the numbers as that, following routines laid down by custom and habit. In other words, we suffer from a disposition toward narrow thinking and looking.

A number puzzle helps to make the point.

$$2 + 7 - 118 = 129$$

Does this statement hold true? Far from it. With the negative 118, the left side is much smaller than the right side. The challenge is to add one straight line to the expression to make it true instead of false. Take a few seconds and see whether you can solve this conundrum.

Even when facing a puzzle, we tend to think by the numbers. Our minds gravitate in the most obvious direction. Indeed, we should not disdain this very efficient way of putting our minds to work. Remember, it is part of the 90% solution. In this case, the most obvious tactic turns to the minus sign on the left side of the equation. After all, it's what is causing the trouble, making the left side so small. A single vertical slash will change the minus to a plus.

You probably have tried that. You have done the arithmetic. You have already discovered the frustration that the sum does not work out right. $2 + 7 + 118$ yields 127, just 2 short of the target 129. Could you have done the arithmetic wrong? You probably rechecked it. Yes, it's 127, not 129.

Can you think of another solution? In fact, there are at least three separate solutions to this puzzle. But finding the three requires breaking assumptions you may have been making at the outset. It requires exercising the theme of this chapter, thinking broadly and adventurously. Take your time and see what you can do, because the next paragraphs will reveal all.

Solution 1. Put a vertical line through the equals sign. This changes "equals" to "does not equal" in standard mathematical notation, making the statement true. While some people think of this quickly, a mental block tends to conceal it. The directions say add a single straight line to make the expression true; we tend to read that as making the equation true, that is, making both sides equal.

Solution 2. This also depends on the equals sign. Start at the left end of the top bar of the equals sign and make a straight line extending diagonally upward to the right. This turns the equals sign into a "less than or equals" sign, and makes the expression true: Indeed, the left side is less than or equal to the right side. The same factor mentioned for solution 1 tends to block this solution from view.

Solution 3. This solution cuts in another direction entirely. It will probably surprise you. Turn to the plus sign on the left. Put your pencil on the left end of the crossbar of the plus and make a vertical line upward. This turns the plus into a four. Check the arithmetic. At last, you have your equality. A different factor from those mentioned above blocks this solution. Perceptually, we tend to see the numbers as one part of the problem and the relations (plus, minus, equals) as another part. We tend to focus on the relations, or the numbers, but not on turning a relation into a number, which cuts across categories.

This is nothing but a puzzle. But, as do many such puzzles, it illustrates the inherent narrowness of thinking and the importance of breaking boundaries. You may have found one or more of the solutions to the above puzzle. If you did, chances are you made one or another mental move that helped you to get beyond the barriers that concealed the solutions. You might have questioned your assumptions: "What am I taking for granted that I shouldn't?" You might have scanned the equation for every possible place to put a straight line: "Would it make any difference there, or there, or there?" You might have looked for an odd place to put a straight line: "Chances are it's not where I'd expect; so let me look where I wouldn't expect."

In exercising such tactics, you were demonstrating an aspect of reflective intelligence, using the reflective power of the human mind to nudge your experiential intelligence in broader more adventurous directions. Amazing in its powers, experiential intelligence nonetheless tends to operate in a somewhat narrow, stereotyped way, unless we give it a nudge.

The disposition to think broadly and adventurously pays dividends in looking at art as it does in other realms. To be sure, simply giving looking time discloses much more than we usually see. However, the stolid patience of giving looking time eventually lets experiential intelligence run down. We can see much more in

works of art by nudging our perceptions outside the tracks they spontaneously follow.

Car Drying

What is it like to make your looking broad and adventurous? Figure 9 gives us a chance to try and see. It's a 1953 photograph by Jack Manning called *Car Drying.* As in the last chapter, there follows a stream-of-consciousness seeing of the work. It begins with giving looking time and moves into some strategies for broad and adventurous looking.

Time	Perceptions	Comments
1st min	Car. Lights. What's going on? Car drying . . . they must have painted the car. It's on the assembly line. The lights heat the paint and dry it. Beautiful, all the lights. The lights echoed in the shiny paint. Light in black, like the sky.	*Just giving looking time, letting the eye do its work.*
2nd min	Cool, hot? It has to be hot. But with the dark and light it looks cool, oddly. Why a car? That's all American. Here is the American baby at birth— shiny, sleek, under the delivery room lights, its code number written on the windshield.	*Giving looking time, questions emerging.*
3rd min	The body of the car almost invisible, the reflections show us where the car is. There is no car but for the lights. It's a Studebaker, says so on the back. A classy car with shiny paint.	*Letting more perceptions emerge.*
4th min	Let's reach for something. What surprises us? That it's all light and dark. Inside, outside. The lights surround the car yet sit within the car in their reflections, outer space and inner space. Abstract design, yet it represents something. Beauty in an industrial setting, a paradox.	*Broadening looking by looking for surprises.*
5th min	What else surprises? Nothing. Let's look for motion, not literal motion, but a feeling or suggestion of motion. The lights zoom away like a tunnel,	*Broadening looking by looking for motion.*

9. Jack Manning, *Car Drying,* ca. 1953. Black-and-white photograph, 14 × 18 in. Courtesy of Jack Manning.

Time	Perceptions	Comments
	like the motion of the car-to-be-born. Which way is it moving? We're looking at the back. The car seems to move with the lights, away from us, deeper into the picture plane. The highlights around the edge of the car boost the sense of velocity. Of course, it's actually still, or perhaps moving very slowly on the assembly line.	
6th min	Meaning? Who knows. Just a visual statement. Or, from earlier, the American dream, the paradox of assembly-line loveliness, the universality of form, how form and symmetry and light and luster create beauty even when we need none, when it's just mechanics, getting the car painted. No strong evidence for this interpretation, just a reasonable whimsy.	*Broadening looking by looking for an interpretation.*
7th min	Space and negative space. The black mass of the car, centrally. The dark space around it, full of light but dark, a shaft extending away from us. The car-shaped hollow the car occupies. The space between the car and the walls, complexly curved, the negative impression of a car. The space *inside* the reflections on the car, a mirror universe of the outside, curved, complex, Einsteinian.	*Broadening looking by looking for the handling of space and negative space.*

The Outreaching Eye

The log above gives a personal seeing. Your eye and mind might find other paths altogether. But no matter. It illustrates the potent trick of looking with one's voice, cuing the eye with words and categories that send experiential intelligence off in fresh directions.

The first minutes demonstrate the natural fecundity of giving looking time, the readiness of vision to find paths and follow them. Quite spontaneously, cultural and historical knowledge informs a basic reading of the work: What is going on in the image, the car as a characteristi-

cally American image, the delivery room association, and like themes emerge.

The fourth minute brings a call for surprises, one of the simplest most powerful things to look for. What is surprising here? Dualities, for one thing: the outer space of lights and the inner space of their reflections, the photo as both abstract design and real scene, the two visions tugging at one another. Beauty incarnate in a practical industrial setting.

The fifth minute brings a call to see "motion" and, with that cue, the dynamics of the photograph fall into place, the receding motion, the streamlining of the car. The sixth brings a probe for meaning, leading to a possible interpretation. In the seventh, we visit the spatial dimension, sensing the masses and emptiness hugged together in the space of the photograph.

Thus we find self-cuing helping experiential intelligence to change directions, casting a net widely to find seeings that otherwise would be missed.

Expanding Perceptions

Half the trick of expanding perceptions might be called "looking for." Instead of letting yourself respond with your experiential intelligence to whatever occurs as your eyes roam over the work, set yourself a mission. Direct yourself to look for particular sorts of things. You can look for what awaits in works of art—features meant to be seen. And you can look for

what hides—the technical devices that help the work to achieve its intended impact. When you do this, you are aiming your experiential intelligence at chosen targets, rather than just letting it do its thing.

The other half of the trick concerns what specifically to look for. You choose characteristics that make your looking broader and more adventurous, that open your eyes to sides of the work that otherwise stay invisible. For instance, you might . . .

- Ask "What's going on here?" If there's an event or story you haven't figured out, do so.

- Look for surprises—a startling color, an odd object, an unexpected relationship. Where and how does the work surprise you, in big ways or in little ways?

- Look for mood and personality. What mood or personality does the work project? Never mind if it doesn't show a person or animal. Strong moods or personalities often shine through abstract works, landscapes, or still lifes.

- Look for symbolism and meaning. Does the artist have a message? What might it be?

- Look for motion. Many works depict motion directly and vividly—running horses,

a bird in flight. Others do not represent action, but the lines, the texture, the spatial form, carry a powerful message of motion anyway. Remember, for instance, *The Starry Night.* In that entire dynamic drawing, the only thing that actually moves is the rising smoke, but the swarming motion of the sky and landscape figures centrally in the whole experience and meaning of the work.

■ Look for capturing a time or place. Many works engulf the viewer in a very specific spatial and temporal locus: for example, Paris in the fog, 1890.

■ Look for cultural and historical connections: the car as central to the American way of life, for instance.

■ Look for space and negative space. Sculpture and many works of art on a two-dimensional surface represent bodies in space. Look for the shapes of the bodies, and the shape of the space itself, including the space around the objects, often called "negative space."

■ Look for specific "technical" dimensions. Ask yourself to notice colors and how they relate; the major shapes and how they balance or unbalance one another; the use of line, jagged, smooth, quick, careful.

■ Shift your scale. Look for the big things, the small things, overall structure, detail.

■ Look for virtuosity. What features of the work appear really hard to do? What features appear easy but might actually be hard?

This list is open-ended. Add your own favorite features to look for, by all means. It is not intended to be used fully or in any particular order. Skip around and sample as you wish.

But it is not unbiased. The entries slant somewhat toward what I earlier called what awaits rather than what is hidden. They emphasize features that the artist probably wanted us to find and savor, less often pointing to the technical moves of the artist that indeed also merit attention. This bias allays worries about an overtechnical approach that "murders to dissect."

Another point about the list: In the spirit of making the best use of experiential intelligence, these are all no more than nudges. When you tell yourself to look for surprise, mood, or motion, you say nothing about what surprise, mood, or motion to find. It's the job of your experiential intelligence to follow through on the injunction, making sense of the art in terms of the category you have called up. Left entirely alone, experiential intelligence often runs on narrow tracks. But, given a nudge by reflective intelligence, experiential intelligence is

remarkably creative. You can even ask your experiential intelligence to look for motion in a work that in no literal sense depicts motion. Your flexible experiential intelligence will try to make a match!

An Image for You: *Battle of Rorke's Drift*

Figure 10 is a linoleum relief print by South African artist John Muafangejo.[37] It depicts in stylized but dynamic fashion a key event in the early history of South Africa. In 1879, the Zulu and the British fought a war in the region of South Africa now called Natal over control of the territory. One key engagement occurred at a British fortification at Rorke's Drift. There, about 120 British soldiers successfully held the fort against a large force of Zulu warriors. In the end, the British won the war and gained control over lands that previously had been the dominion of the Zulus.

Give looking time with the *Battle of Rorke's Drift*. And make your looking broad and adventurous. What can you find out about it? As before, you may want to keep a "seeing log" or not. In any case, somehow note to yourself your progress as you discover the subtleties of John Muafangejo's image.

The Art of Thinking

Just as we can cultivate broader more adventurous looking at art, so in general we can cultivate broader more adventurous thinking.

The value of such thinking finds its most secure testimony in the history of human civilization and the singularly creative individuals that have shaped its culture and politics. We honor the musical insight of Mozart, the political inventiveness of Gandhi, the space-bending thinking of Einstein, and the verbal virtuosity and human insight of Shakespeare. Each of these, and innumerable other figures, made their contributions by stretching or breaking the conventions of their day and securing a foothold on new heights.

With all that said, we should not identify broad and adventurous thinking solely with paragons of invention. In the everyday work and play of people, innumerable opportunities emerge for broad and adventurous thinking. Such thinking should not be seen as the manna of genius but the bread and butter of getting along in the world just that much better than you otherwise would.

By way of illustration, consider this tale not of a Pythagoras or Picasso, but an ordinary fellow—let us call him Warren—who hated his boss.

Warren hated his boss, but he loved his job. A businessman with significant responsibility, he enjoyed working with his colleagues, thrived on the challenges, sought reasonable advancement but without jealous rivalry. The world was his oyster, except for one irritant: that overbearing, overrated, overconfident fellow that happened to be his boss.

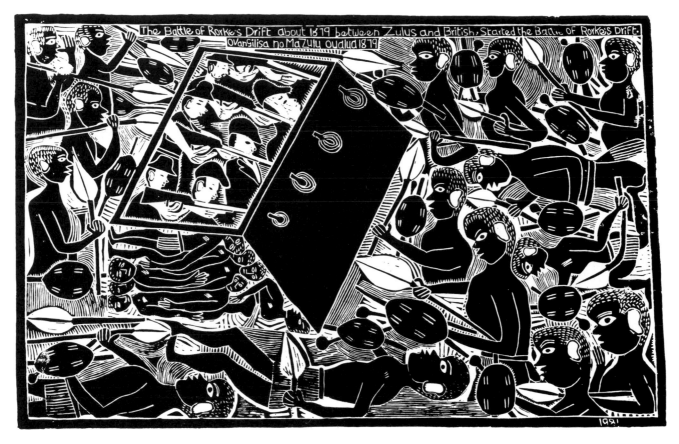

10. John Muafangejo, *Battle of Rorke's Drift, about 1879 between Zulus and British,* 1981. Linocut, 18 × 20 in.
© John Muafangejo Trust, 1993.

For a while, Warren bore up. Maybe something would change. Perhaps a bridge would get built across this chasm of personal style. But after a while, all seemed hopeless. Finally, Warren resigned himself to face up to the problem. He would have to deal with it somehow.

Warren thought of going to a "headhunter," one of these experts who helps find positions for people. He felt confident in his abilities. He could find another position. He could start the corporate climb again. He had the vigor and the taste for it.

But before that crucial step, he did some broad and adventurous thinking. "What am I taking for granted?" Warren asked himself. "What would I really like? What would be the best of all possible worlds?

"I'd like my boss to move, not me," he concluded. And thought how that might happen.

Warren did indeed go to the headhunter—and gave him his boss's name.

The headhunter found a very attractive offer for Warren's boss. His boss took the offer and left the firm. Warren was promoted into his boss's position.[38]

Tales like this help us to reach for the disposition of broad and adventurous thinking. They offer visions of accessible creativity, something gratefully short of the Mozartian. If we ask how to foster this kind of thinking in general, it's important to remember again that the focus here falls not on some neatly packaged bundle of skills or strategies but on thinking dispositions, matters of attitude and habit that do not lend themselves to a do-the-following-ten-exercises approach. As urged for giving thinking time, so for making thinking broad and adventurous, such things are taught more by enculturation than by instruction. One works to build a culture in the school, or home, or other setting that honors and encourages broad and adventurous thinking.

For an inside view of the kind of mindset that steers one's mind toward broad and adventurous thinking, it's worth another visit to that inner dialogue between the Holmes and the Watson in each of us.

Holmes: Narrow thinking is the thief of progress.
Watson: My dear Holmes, I wonder whether in these periods of inactivity you are not developing an unhealthy inclination toward aphorisms.
Holmes: Ah, Watson, it is true that philosophizing makes a poor substitute for the genuine hunt. But with not a case in hand, nor even the hint of one, I am thrown upon other amusements. I will stand by it. Narrow thinking is indeed the thief of progress.
Watson: And what precisely do you mean by this assertion?
Holmes: Precisely this: that people are too comfortable with the obvious. It is the natural inclination of the mind, to dwell comfortably in the

obvious. If, for example, I should drop a pencil, I do the obvious thing. I pick it up.

Watson: Well indeed. And what else *would* one do?

Holmes: Perhaps let it lie. To let an antagonist trip upon it. To see who is gracious enough to pick it up for you. To conceal an unsightly tear in the carpet. To study how a pencil falls and what that may tell you about fallen things at the scene of a crime. Who knows? A dozen reasons. A hundred. You see, if we do not exercise our thinking in a broad and adventurous manner, we will simply remain walled up in our own habits and patterns.

Watson: Surely, Holmes, this is just a matter of intelligence.

Holmes: Ah, but Watson, what *kind* of intelligence? Narrow thinking comes naturally to that practical intelligence that gets us through 90% of the day, the 90% solution so to speak. But what about the rest of the time? For the 10% solution, we need to take charge of our minds. We need to lift ourselves out of the obvious, which is very often misleading, and cast about in fresh directions.

Watson: Holmes, as always, you are insidiously persuasive. But I remember our conversation about giving thinking time. And here, as there, I feel it imperative to ask about *when.* You do not expect me, or even yourself, to display conspicuous creativity in calling a cab or addressing a letter.

Holmes: Not for the most part, no. But at the right moment, yes. Timing is everything, Watson.

Watson: But timing by what clock, with what marks on the dial? Surely I can tempt you into some specifics.

Holmes: Not specifics, Watson, generalities. The general rules that have wide application. In fact, I believe we mentioned a couple already for giving thinking time that serve us well here also. High stakes and pressing puzzles. Either one, you will recall, was a reason to give thinking time. Additionally, both are reasons to make our thinking broader and more adventurous.

Watson: I would think that when stakes are high, one might incline to be conservative.

Holmes: So one might be in one's ultimate decision. But a conservative leaning in the final decision has no reason to avoid an adventurous mental exploration of the possibilities. Perhaps a possibility will turn up that is on the one hand strikingly original and rewarding and on the other quite safe. Besides, it is worth remembering that a good many men and women have chosen to take their chances with the risky path, despite high stakes. And rather often brought it off.

Watson: And often *not* brought it off. But I take your point. Let us suppose then that we set our minds on adventure. On *mental* adventure at least. Whether our physical bodies and overt actions follow along, we will worry about later. How do we go about this adventuring?

Holmes: Oh, Watson, I am not a walking tutorial in the techniques of imagination. Do you want rules to follow? Well, there are the rules of brainstorming. There are the tricks of random association. There is the inventive path of metaphor and analogy, where absurdities sometimes lead along to resolutions that make the utmost practical sense. But really, these are questions of technique. The most important step is not technique at all, but one of posture, of mindset, of attitude, of orientation. Call it what you will, it is that reaching out beyond the obvious by any manner whatsoever with an open spirit.

Watson: Holmes, you are an inspiration. If there were an adventurous risk I could take right now, I believe I would take it. Although, may I confess, I am rather glad that there is not.

Making Looking Clear and Deep

Falling into Place

What is it to have a deep vision of a work of art? The British poet W. H. Auden gives us a wonderful sense of this in his well-known poem "Musée des Beaux Arts." In the poem, Auden points up an insight about suffering recognized by the old masters of painting: Ordinary life goes on regardless.

Auden selects his evidence: a painting by the sixteenth-century Flemish painter Brueghel called *Icarus.* According to Greek mythology, Icarus, soaring on wings attached to his body with wax and enraptured by the experience, flew too close to the sun. The wax melted and Icarus plummeted into the sea to drown.

Auden centers on something most curious about Brueghel's painting—Icarus's plunge is peripheral, a minor event in the lower right hand corner of a painting dominated by a peasant plowing a field. Auden sums it up this way:

In Brueghel's Icarus, for instance: how everything turns
Away quite leisurely from the disaster; the plough-man may
Have heard the splash, the forsaken cry,
But for him it was not an important failure; the sun shone

As it had to on the white legs disappearing into the green
Water; and the expensive delicate ship that must have seen
Something amazing, a boy falling out of the sky,
Had somewhere to get to and sailed calmly on.

Auden packages in poetry what we would all like to find in a work of art—insight into its essential message, logic, or expression. Auden offers us one kind of insight, an interpretation, almost a moral in Aesop's sense. But there are other kinds as well. Insights into a work may take the form simply of realizing fully in one's experience its expressive power to move us, or recognizing its subtle technical means. Insights can concern the whole work or just an aspect.

If you give looking time and look broadly and adventurously, you will certainly discover much. With luck, you may find the kind of insight Auden offers us about Icarus. But it is all too easy not to. Time and broad thinking can still just skim the surface.

What could be more natural? As mentioned earlier, experiential intelligence tends toward the "fuzzy." We reach easy conclusions that may not stand up to more careful scrutiny. We catch

impressions that may mislead. We lump ideas and feelings and images together when we would understand better what it all means if we separated them out. This holds true for looking at art as much as for any other demanding encounter with a complex world. And, far from eliminating fuzziness, just giving looking time and looking more broadly and adventurously often give us more to be fuzzy about.

To reach a vision of a work truer to the work, something clearer and deeper, we have to work for it. We have to muster our reflective intelligence. We have to use it to direct ourselves to get more systematic and analytical.

Napalm

Entitled *Napalm,* Figure 11 is a 1985 bronze sculpture by Puerto Rican sculptor José Buscaglia. Note that the work is fairly large, 62 inches high. Although a photograph can never give us the proper experience of a sculpture in the round, the front view here affords reasonable access to the work. In keeping with previous chapters, here is a seeing of this work that illustrates the ideas above.

Time	Perceptions	Comments
1st min	Napalm. Burning. War. That's a rib cage. The people are fleeing from the fire. Some of them	*Giving looking time.*

Time	Perceptions	Comments
	are the flames. The gestures of their arms mimic the flames. Curious, the one figure falling downward on the bottom left, the only one not rising. Why?	*Letting questions emerge.*
2nd min	Certainly this is a protest piece, napalm a vicious weapon. The rib cage stands upside down. Nothing coming. Broaden . . . look to light. Full of highlights. The highlights off the bronze give it more glitter and motion.	*Giving looking time.* *No response, so broadening perceptions.*
3rd min	Hands. That motion, some of it comes from hands. The piece makes you conscious of hands, so many figures have their hands outthrust. The rib cage is what's left of a human being. Are these figures souls?	*Giving looking time.* *Letting questions emerge.*
4th min	Broaden . . . look for surprises. The whole thing is a surprise, the inverted	*Broadening again, looking for surprises.*

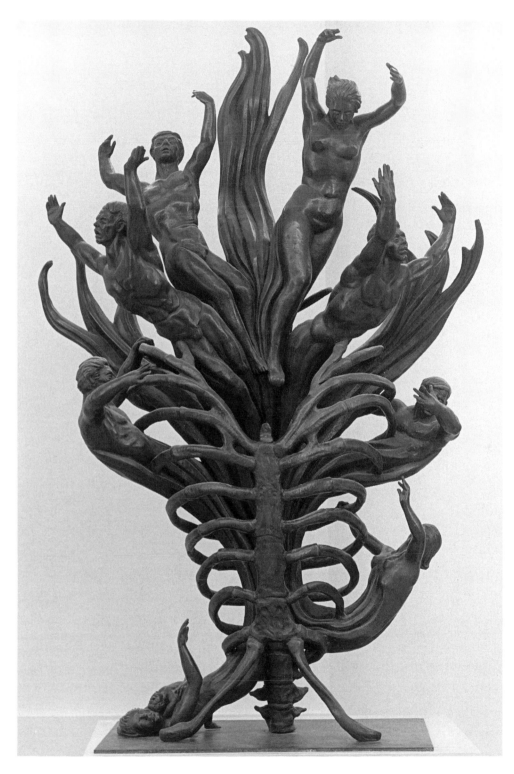

11. José Buscaglia, *Napalm,* 1985. Bronze, 62 × 45 in. Courtesy of José Buscaglia.
Photograph: Michael Marsland.

Time	Perceptions	Comments
	rib cage, the people as flames, flames as people, people as souls. It's brutal in its statement.	
5th min	Time to dig deeper. The moral seems easy: Napalm is a weapon that should never be used. Plenty of evidence for that in the horror of the image. But beyond the general moral, what are the puzzles?	*Decision to make looking clear and deep.* *Looking for puzzles.*
6th min	There's that figure in the lower left, falling downward. Why that? A puzzle, different from the rest. Mask it with your thumb. That makes the other lower figure, on the right, conspicuous. Mask both. The sculpture gets top-heavy.	*Return to the puzzle of the lower left figure, mask with thumb to try variation.*
7th min	Mask just the bottom right figure with your thumb. Then the bottom left figure seems separated from the main group. The bottom right	*More masking to explore variations.*

Time	Perceptions	Comments
	figure bridges between the bottom left and the main group, making the piece more unified.	
8th min	What about the expressive role? The bottom left figure collapses, dies, like an ember fallen from the fire. There's a line of motion from the bottom left figure through the bottom right figure and upward along the right edge. Those bottom figures give the whole an upward-sweeping gesture. Notice the arm on the bottom left figure. Even though the figure falls downward, the vertical thrust of the arm leads the eye upward into the rib cage and the flames.	*Continuing to examine the puzzle of the lower left figure.*
9th min	What do we have here? Can we spell out a conclusion? We have a technical insight into the composition of the piece. The bottom figures pre-	*Summing up.*

Time	Perceptions	Comments
	vent the sculpture from seeing top-heavy. They also make up part of a continuous gesture from the bottom of the sculpture to the top. They also remind us that after the pain there is subsidence, death. The evidence: from masking the figures, seeing how this changes the look of the whole.	
10th min	Look back. There is the dying figure on the lower left, the upward reaching arm, the rightward figure, the overall gesture, bodies of flame, flame of bodies.	*Reseeing the entire work to recover a sense of the whole.*

Focusing In

This seeing of *Napalm* begins simply with giving looking time. Cultural and historical knowledge about war, napalm, and the long tradition of protest through art, immediately inform the seeing. Minutes two and four bring some simple strategies for broader, more adventurous looking: asking after effects of light and surprises.

Minute five begins with a deliberate decision to look more deeply. A brief exploration of the basic meaning of the work finds it clearly a protest piece. Then we go back to a puzzle identified in the first minute, the bottom figure on the left, the only one not rising upward.

There follows a close exploration of how this figure fits into the work as a whole, an exploration that soon expands to include the bottom figure on the right. This is a technical probe, examining how these figures participate in creating the overall impression. Experiments masking the figures with a thumb reveal how important their treatment is to the sculpture as a whole. Note how this analytical way of looking does not leave experiential intelligence behind. On the contrary, it depends on experiential intelligence to gauge the impact of masking the lower left and lower right figures.

How does all this color our experience of the sculpture? For one thing, it yields technical insight. We come to understand something about why Buscaglia shaped it as he did. We have probed a hidden, rather than an awaiting, aspect of invisible art. While the sculptor certainly did not envision us analyzing his tactics, we can undertake exactly that to satisfy our curiosity.

But how does this reverberate in our aesthetic experience of the work? Does it leave us stranded in some Sahara of academic analysis? Not so in the seeing above. The technical in-

sights lead back into an intensified recognition of the gestural sweep of the sculpture and the merging of bodies and flame.

To draw a moral, often the hidden—the technical mechanism of a work—is a gateway to what awaits—the aesthetic dimensions of the work.

The Analytical Eye

None of this says that we always have to be interested in digging deeply. People often walk away from a work of art satisfied with much less. Sometimes your whole encounter with a work may set your mind against an analytical investigation. How analytical to get, how deep to dig, is a choice you make. But how to go about getting more analytical is a craft people need to know more about, in order to have the choice. What are some parts of this craft?

Find a focus. . . .

■ Go back to something that surprised you. Ask: Why did the artist do that? Just to be provocative? Was there a message? How does it fit into the whole work?

■ Go back to something that interested you, a sense of motion in a painting depicting a still scene, an emotion powerfully expressed, anything. Ask: How did the artist get that effect? And why—how does it contribute to the whole work?

■ Look for something that puzzles you about the work. Try to unravel the puzzle.

Consider examining not just what we called earlier what awaits, effects the artist meant you to see, but what hides, the technical underpinnings of the work. . . .

■ Make mental changes. What if you changed a color, a material, removed an object? Use your thumb or hand to mask objects and to explore how this changes the work's impact.

■ Look for "reinforcement" across the work, ways that the artist handles things in one part to strengthen an effect in another part or an overall effect.

■ Look for technical features of the work: the handling of color, form, line, composition, the way the layout of the work controls the motion of your eye around the work. Probe how the work functions as a mechanism to engage your vision and thinking.

■ Compare the work with another you know that relates in some way—by the same artist, or from the same period, or concerning the same topic. What are some similarities and contrasts? And why are they there; what do they imply?

Think in words, to help you manage your line of reasoning. . . .

- Articulate to yourself your questions and possible resolutions.

- If you are interpreting the work, put into words what you take the message to be.

- Look for evidence in the work of conjectures you make. Are there parts of the work that seem inconsistent with what you are thinking?

Sum up. . . .

- In general, try to come to some specific articulated, well-evidenced conclusions about the work and your experience of it.

In plumbing a work clearly and deeply, one kind of summing up you might attempt is an evaluation. How good is the work after all? Is it mediocre, competent, fine, exceptional? How does it compare with other exemplars of artistic creativity in the same style or genre? Such connoisseurial conclusions are often considered an important part of responding to art.

But caution! Careful evaluation is hardly a necessity except for curators and critics. And it may be a distraction. You can spend time with a

work, explore it, get engaged with it, find interesting things in it, without ever asking yourself, "All in all, how fine a work do I think this is in comparison with others?"

If you do ask yourself that question, remember that a summative judgment represents much more than a visceral response. It involves thoughtful comparison and the marshaling of reasons. It demands not just an intuitive but an articulate appraisal. It addresses not just whether you like or dislike a work, but how good you think the work is in an at least somewhat more objective sense.

None of this says that reactions of liking or disliking have no value. Certainly they do. They are part of our experiences of works and they may well gesture toward a summative judgment. But they are more points of departure than places of arrival.

An Image for You: *Fuji at Sea*

Although what is good and what we like are not always the same, here is a work that is both good and easy to like. Figure 12 offers *Fuji at Sea*, woodblock print number 40 from the famed series of black-and-white prints "One Hundred Views of Mount Fuji" by the nineteenth-century Japanese master artist Hokusai. These prints were issued in three booklets. As in this image, usually a pair of facing pages constituted a single image in two panels. The distinctive conical

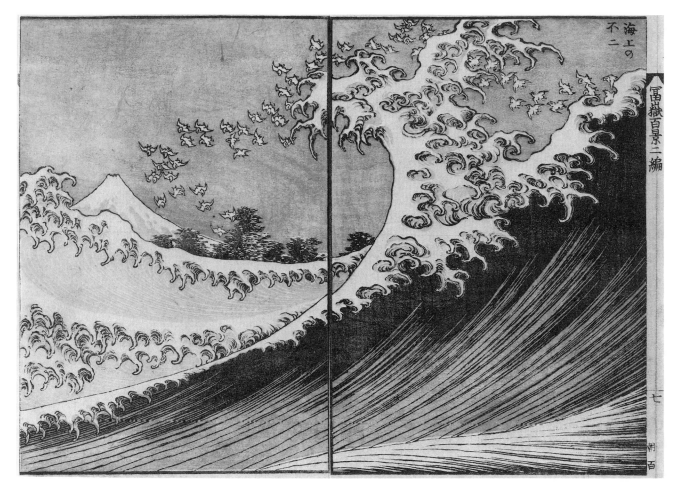

12. Hokusai, *Fuji at Sea* (#40 from "One Hundred Views of Mount Fuji"), 1835. Woodblock print, black with gray tone, 12 × 9 in. including margins. Reprinted by permission of George Braziller, Inc.

profile of the volcano Mount Fuji appears in some form in every one of these prints, in this case in the upper left. For a whisper of cultural backdrop, Mount Fuji has rich symbolic meanings in the Japanese culture; Hokusai apparently viewed it as a symbol of eternity.[39] Besides any symbolic significance it may have, this print from Hokusai's compendium is a marvel of visual design. Give looking time, make your looking broad and adventurous, clear and deep, and see what you can discover about it.

The Art of Thinking

In familiar everyday situations, we are well served by a rough take. The details and the depths matter little. This is the get-through-the-day 90% solution of experiential intelligence. The 90% solution serves looking at art poorly, because art worth looking at is almost always an exercise in subtlety. To miss the subtlety is to miss much of the art in the art. Looking at art falls into the 10% zone where we need more reflective control to make our looking clear and deep.

The same sort of disposition applies to demanding thinking in general: We need to make our thinking clear and deep. Often invention itself depends on the depth of people's logic. Discoveries are reasoned out rather than thought up out of the blue. A classic case is Alexander Fleming's discovery of penicillin in 1928. Exper-

imenting with bacterial cultures, Fleming was troubled by a typical laboratory problem. The nutrient substance in the culture dishes also was a congenial home for molds. These molds, started by spores floating in the air, generally were the enemies of the investigator. They could ruin an experiment.

One day, Fleming found himself faced with just such a threat. He discovered a blue mold, *Penicillium notatum,* growing on one of his culture dishes. He might have thrown the ruined culture out. However, he noticed something curious. The bacteria also thriving on the nutrient were not growing close to the mold. Near the mold was a no-man's land, where the bacteria could not penetrate. What was it, Fleming asked, that kept the bacteria out? Something from the mold it seemed, but what? Starting with this question, Fleming went on to refine penicillin, the first of the antibiotics, substances that were products of life but worked against life—especially, the life of harmful bacteria.

Notice that Fleming's discovery involved thinking carefully and analytically about what he saw. He had to perceive the puzzle in a situation and follow the clues to its solution. Notice also that Fleming's background knowledge about molds and bacteria played a critical role in his discovery. He used his knowledge. You or I, unfamiliar with the typical behavior of molds and bacteria, would have seen nothing odd. We

would not know what to count as curious and what to chalk up to business as usual. What is odd is a matter of expectations violated. And having expectations is a matter of knowing the terrain.

Much the same can be said more generally about the entire disposition to think in a deep and careful way. Inevitably, such thinking involves not only logic but the exercise of knowledge. The knowledge may be about art, everyday life, nuclear physics, popular movies, or auto mechanics. But the use of knowledge is critical. Therefore, when we create a classroom, home, or other culture to foster clear and deep thinking, we have to encourage people to dip into the well of what they know and to reason carefully about what they perceive.

As in past chapters, the inner voices of our Watson and our Holmes can tell us more about the disposition to think in a clear and deep way.

Watson: Do you remember, Holmes, the adventure of "Silver Blaze?"

Holmes: I do indeed. A curious matter.

Watson: I have always been struck by your reasoning there. Because you took as your point of departure something so ordinary.

Holmes: How do you mean?

Watson: You may recall that I asked you how you got to the heart of the matter. And you gave me a very odd answer.

Holmes: Ah, yes. I will have my little jokes. I said it was "the curious incident of the dog in the nighttime."

Watson: And I replied, you may recall, "The dog did nothing in the nighttime."

Holmes: And I, "That was the curious incident."[40]

Watson: Well, there you have it. To me, it was not at all curious. There was nothing odd about the dog doing nothing.

Holmes: I am afraid, Watson, that you do not always exercise what you know.

Watson: Know. What was there to know?

Holmes: I do confess that I have extensive knowledge of such esoterica as varieties of tobacco or the soils in all neighborhoods of London, which one can hardly expect of anyone without a professional interest. But in this case, Watson, we were nose to nose at the starting gate, if I may be permitted a metaphor from the racetrack.

Watson: Well say what you mean, man!

Holmes: Just this. That you know as well as I that a dog may bark at strangers. That this dog would. But that this dog would not be likely to bark at someone familiar. This is part of your, and my, common-sense knowledge, something we know about the way the world works.

Watson: Indeed. And yet you saw the implication and admittedly I did not.

Holmes: Yes, because I strive not just to know but to keep in mind. To use what I know. To look

carefully and think: Does this make sense? How does it make sense? Do the facts merge together in a coherent story?

Watson: Holmes, I cannot keep up with you in such matters. But permit me one comment. I think you know something else that I do not, something beyond dogs and their habits of barking.

Holmes: And that is . . . ?

Watson: To look for the oddity. The detail that does not make sense. Since criminals are out to deceive, it is likely to be just there that you may find the clue to what really transpired. And, although nature is not, I hope, out to deceive us, if I understand rightly, it is in the nuances, the details, the subtleties, that people of science and medicine often find their insights. In the same way as you. By catching the detail that does not make sense and finding a way to make it make sense.

Holmes: Watson, you are a philosopher indeed! Now then, if I know to look for the oddities, after our conversation, so do you as well. Henceforth, I shall expect more of you!

Watson: And I shall endeavor to live up to your confidence by seeing not as much as you assuredly will, but at least more than I otherwise might.

Making Looking Organized

The Challenge of the Obscure

We have three ways of better looking now—give looking time, make looking broad and adventurous, and make looking clear and deep. Each came bundled with a few rules of thumb for putting it into practice, not a lock-step strategy but guidelines nonetheless. The three pose a puzzle: How do they work together?

The examples up to now suggest another puzzle too. How well does this art of looking work with less accessible works of art? By and large, our examples have not been obscure. They have connected in obvious ways to the human condition and human hopes and dilemmas. Those works of art that have leaned toward the abstract have not been purely abstract. When we face pure abstraction, what happens?

Let us pursue both these questions by way of an example.

Oil Drops

Figure 13 shows a 1956 photograph by Peter Keetman, *Oil Drops*. It, like many other modern photographs, turns to order in nature and physical phenomena to disclose visual pattern and beauty. And sometimes to make a cultural statement of divergence from the traditional subjects of photography. What kind of a seeing of it can we muster? Here is one.

Time	Perceptions	Comments
1st min	Lovely, the droplets. On a metal surface, it seems. Beads reflecting, all different sizes. Each the same, with the same reflected image of a cross. What's the physical thing being reflected? The delicate shading of the droplets is amazing. The reflection is clearest in the largest drop. They seem like bodies in space, planets adrift in their own private cosmos.	*Giving looking time.* *A question emerges.*
2nd min	Images reflected in the drops aren't quite identical. The reflected cross is differently positioned. Curious. The center of the cross seems to tend toward the side of the oil drops closest to the center of the image. Why?	*Giving looking time.* *Another question.* *Broadening to look for tactile impressions.*

70

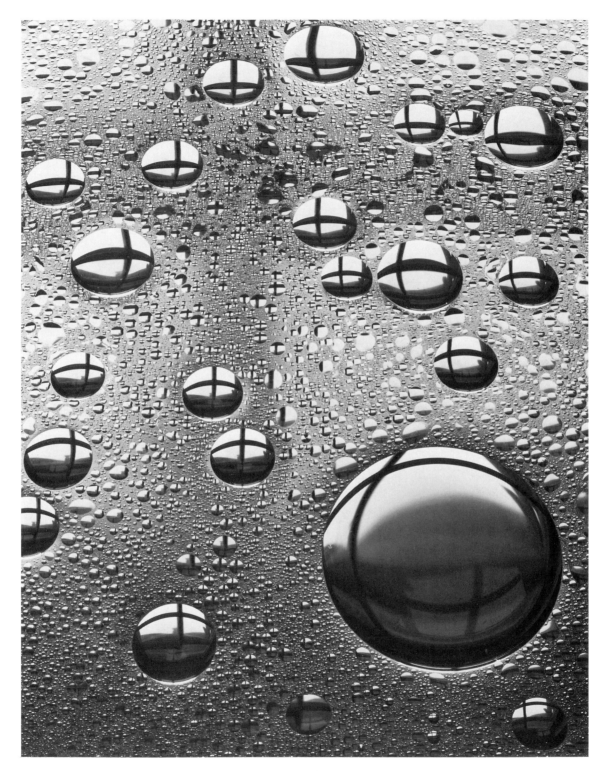

13. Peter Keetman, *Oil Drops,* 1956. Black-and-white photograph, 12 × 9 ½ in.
Courtesy of Peter Keetman.

Time	Perceptions	Comments
	But the dazzle of it—this scatter of brilliant globules! Imagine what it would be like to touch. You can almost feel the oil, its slick, sliding iridescence, the texture especially intense on the large globule bottom right.	
3rd min	How small do they get? As small as you can see. How large—the largest on the lower right. It's a continuum, all sizes. Notice the background, not uniform, some areas brighter, some darker. Wait! A discovery. On the surface of the plate there's a kind of shadowy cross, its center in the upper left quadrant. This must be another reflection of the cross apparent in the globules.	*Broadening to look for the range of drops.* *Noticing a key feature.*
4th min	Broaden . . . is there meaning here, Christian symbolism in the cross? No reason to think so.	*Broadening to look for meaning. An interpretation*

Time	Perceptions	Comments
	The industrial world implicit in the oil? No reason to think so. Closer to physics than culture, the sheer physical phenomenon. Broaden . . . surprises? The visual tension between droplets on a flat surface and their guise as spheres floating in space at different distances. The large globule in the lower right, larger by far than all the others, startlingly large, almost dominates. But—aha!— balanced by the shadowy cross in the upper left.	*contemplated, dismissed.* *Broadening to look for surprises.* *The interpretation comes to mind again, again dismissed.*
5th min	Broaden . . . the mood? Technical, physical, behold physics at work, the machine of the world doing what it does.Or fantastic, a swarm of silver spheres. Broaden . . . motion? Suspension. Stillness. An array at rest. The spheres lie circled by their own boundaries, not wanting to go anywhere.	*Broadening to look for mood.* *Broadening to look for motion.*

Time	Perceptions	Comments
6th min	Look deeper . . . a puzzle. A simple question: What's reflected? Look to the large globule, where you see more. A room, a scene? Won't come clear, enticing but unresolvable. Is the cross the reflection of the crossbars of a window? Unlikely; the different positions of the reflection of the cross in the droplets suggest it's close to the plate. An enigma. Maybe this is the insight: Part of the experience of the work is how it lures you into a game of identification that you cannot win, tangling you in pursuit and puzzlement.	*Looking clearly and deeply at the cross.* *Some ideas but can't confirm them.* *Settle on the puzzle as part of the experience.*
7th min	Look again, resee. The cosmos of globules. The sharp lines of the crosses. The texture of oil, the metal almost sweating. The shadowy cross, a counterpoint to the sharp clean crosses reflected in the oil drops,	*Reseeing the whole work, re-experiencing what it offers.*

a counterbalance to the large globule in the lower right. A stillness of balances, each drop stable, unmoving, its perfect liquid surface mirroring an inscrutable world.

Orchestrating the Eye

The yield of experience is surprising from so simple and abstract an image. Despite its lack of an obvious human subject, this sensuous photograph easily sustains our engagement. Compulsive makers of meaning, the eye and mind turn to possible interpretations, but ones that find little evidence in the work. Even the simple question of what actually is reflected in the oil drops proves evasive. In the end, part of the experience of the work becomes how it puzzles us, how it stands mute and will not answer.

Here some background knowledge about recent and modern art helps. You do not have to have been around such art that long to realize that often works tease rather than tell. They puzzle and lead on without a firm conclusion. Part of the game is figuring out what kind of a work you face, whether the work is supposed to reveal or conceal, present a message or pose a mystery. The mind prepared for modern and contemporary art does not routinely expect closure.

All this emerges from a rough and ready order in the application of our three tactics, a way of orchestrating the resources of experiential intelligence with reflective intelligence. We began with giving looking time, simply looking, keeping engaged, giving the work a chance to show itself to us. We continued by making our looking broader and more adventurous by looking for physical feel, meaning, surprise, mood, and motion. And we went on to probe a specific puzzle: What actually is reflected?

There is absolutely nothing wrong with a different order for these three ways of approaching a work. But there is a certain grace to the progression from giving looking time to making the looking broader and more adventurous to making the looking clearer and deeper. If you do not give looking time at the outset, you are hardly giving the work a chance to speak for itself. You are jumping in with categories and queries that may preempt what the work wants to tell you. If you move directly into analyses and interpretations, your push toward clarity and depth may come at the cost of a broader seeing of the work, from different angles, through the lenses of different categories. It is the broad and adventurous looking that often yields the puzzles most worth pursuing.

And when are you done? When you want to be. Perhaps when you find yourself discovering less as time goes on. But you can almost always discover more if you try. When you have invested as much as you care to, perhaps that is the simplest answer.

Notice the closing ritual: A kind of reexperiencing of the work that cashes in on the perceptions along the way. Now you can review with the fluency earned from knowing your way around the work. In summary:

- Giving looking time slides into . . .

- Making your looking broad and adventurous. Which at an opportune moment shifts to . . .

- Making your looking clear and deep. And when you feel done, you round up with . . .

- Reviewing the work fluently, marshaling all you have discovered.

All this orchestrates experiential intelligence to draw from the work of art both richer experience and revealing insight.

An Image for You: *Your Gaze Hits the Side of My Face*

Figure 14 presents a black-and-white 1981 photograph by Barbara Kruger. Listed as untitled, the photograph nonetheless tempts us to name it after the phrase down the left side. Like

much contemporary art, this work demands that we look to the puzzles it poses and the ideas it arouses, not just the visual surface.

We are not used to an art of ideas. In his *The Painted Word*, Tom Wolfe needles this trend in recent art. "Frankly," he writes, "these days, without a theory to go with it, I can't see a painting."[41] Philip Yenawine takes a more positive view of it all:

> *The* idea *has often replaced the object as the center of art. This is clearly disappointing to some degree—where is the wonderful, meaningful object we can love? The strength of idea-based art, however, is that it forces us to think. While a newscast essentially predigests information, current art is configured to make us chew for ourselves.*[42]

Kruger's photograph is surely an idea work. But it also employs a good deal of visual art and craft in telegraphing its ideas—as Wolfe says, "the painted word." So dig into it. Cultivate the dispositions of giving looking time and broad, deep, and organized looking. Follow Yenawine's advice and chew!

Other Ways of Orchestrating the Eye

The notion of making looking organized is not just an idea whose time has come—it is an idea with a history. A number of authors have urged that making the most of art calls for making looking organized. They have recognized that it is all too easy to stand in front of a work of art and miss much of what the work has to show. This basic fact—what I have called the invisibility of art—has provoked people to suggest systematic ways of looking at art, ways that render art more visible than it would otherwise be.

One of the best-known strategies appears in Edmund Burke Feldman's imposing *Varieties of Visual Experience*.[43] Feldman proposes a four-phase process of what he terms "the critical performance." The phases can be summarized as follows:

1. **Description.** This involves taking inventory of what is in the work: the forms, shapes, colors, people, buildings, and so on, and the technical means employed—how the work was built up in its medium. The viewer should label these elements with words and phrases. Feldman emphasizes that value judgments should be kept out of this inventory.

2. **Formal analysis.** This involves looking at the way the elements of the work are organized and seeking out the "logic" of their organization. How is the work structured and why is it structured that way? Feldman urges viewers to try to defer an outright interpretation.

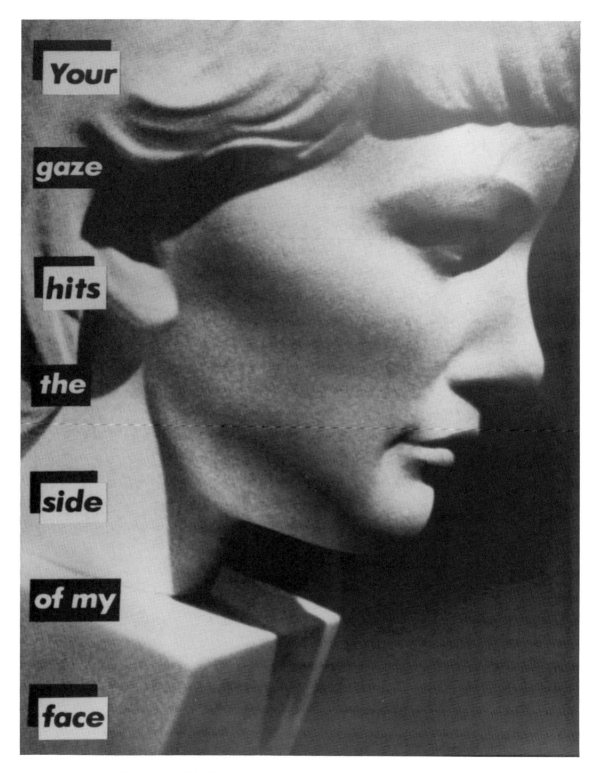

14. Barbara Kruger, *Untitled* (Your Gaze Hits the Side of My Face), 1981. Black-and-white photograph, 55 × 41 in. Courtesy Mary Boone Gallery, New York.

3. **Interpretation.** This involves analyzing the meaning of the work. What does it aim to communicate? What is its message if any? What themes does it deal with? What intellectual or artistic problems does it solve? Feldman warns viewers that value judgments are another matter. Interpretation has to come first, in order to assess a work fairly from a full perception of it.

4. **Judgment.** This is a matter of appraising the aesthetic merit of a work relative to other comparable works. Is it mediocre, a masterpiece, strong in this way and weak in that? How does it stack up? Note that the aim is to assess quality, not personal preference. For instance, it's perfectly possible to like a work you know is mediocre, because it shows, for example, a familiar scene from your home town. In calling for judgment, Feldman emphatically wants not preferences but appraisals of quality.

In much the same spirit, Harry S. Broudy describes a process called "aesthetic scanning" developed by him and R. Silverman.[44] They suggest first looking for sensory properties (shapes, lines, etc.), then formal properties (how elements fit together to achieve unity, and related matters), then expressive properties (meaning, feeling, etc.), and then technical properties

(medium, technique, etc.). A later phase concerns judgment. The scheme is quite similar to Feldman's, except for the category of technical properties which Feldman treats as part of his description phase.

The strategies developed by Feldman and by Broudy and Silverman may seem rather different in style from the present progression through giving looking time, making looking broad and adventurous, making looking clear and deep, and reviewing the work fluently to reexperience its qualities. And they are!

Most broadly, the dispositional approach adopted here highlights very general mental moves such as making your looking broad and adventurous. The strategies of Feldman and of Broudy and Silverman focus on specific characteristics of art and organize the looking process in terms of those characteristics.

Therefore, it's easy to mix the present dispositional approach and these other strategies. If you wish, in giving looking time, you can bear in mind the kinds of categories that they highlight. In making your looking broad and adventurous, you can deliberately examine some or all of those categories, to stretch your perception of a work. In making your looking clear and deep, you can try to reach a definitive account of the work relative to any one of those categories. Recall that in the "Expanding Perceptions" section of Chapter 6, I offered a personal list of features of art that

invite attention. The categories suggested by Feldman and by Broudy and Silverman in effect offer more thorough and organized lists.

You can pay attention to all these categories if you wish. But you don't have to. The dispositional approach is less concerned with a thorough analysis of a work. In their carefully articulated categories, Feldman and Broudy and Silverman aim to cover a work from top to bottom, back to front, technique to meaning to merit. In contrast, the dispositional strategy aims at a rich and intelligent encounter with a work of art more than a thorough analysis. The experience can wind down whenever the viewer wants it to.

So what is the best thing to do? In my view, it depends on what you want. If you want a thorough analysis, you can merge the dispositional strategy with the strategy of Feldman, or of Broudy and Silverman, or any other strategy that highlights what features to look for in what order. Or you can use those strategies alone.

Now for my personal confession: I am often not so interested in a thorough analysis and quite happy with a rich and intelligent experience that falls short of thoroughness. I often find it artificial to step through description, then formal analysis, then interpretation, and so on, but not artificial to give looking time, then to broaden my perceptions, and so on. I often never reach, or even try to reach, a value judgment about a work. I often never try to survey its tech-

nique. My preference leans more toward getting something valuable out of the work than getting everything out of the work. Perhaps this is true of you as well.

However, sometimes I want more, or sometimes the circumstances demand more. When this is the case, strategies like those suggested by Feldman and by Broudy and Silverman are especially helpful. And it is always helpful to bear in mind the categories they emphasize, even if you do not tour through those categories exhaustively. I'm glad to have them in my repertoire. What strategy to use, or whether to use any strategy, is a choice people need to make, and not for all time but according to the needs and invitations of the moment.

One last contrast: These other strategies focus on art specifically. The dispositional strategy aims at generality. It celebrates broad principles of reflective intelligence. Which brings us back to our theme of the art of thinking.

The Art of Thinking

Recently I was walking across the Cambridge Commons toward my office. I passed a middle-aged man sitting with a slightly younger woman on a park bench, engrossed in conversation. I barely glanced at them, but could not help but hear what the man said to the woman as I walked by. Here are his words, close to verbatim, because they struck me so much that I made a point of memorizing them:

I have to. He lied to me and he lied to you. What did he tell you on the phone? Everything's A-okay he said. Well everything's not A-okay.

Wow. I had passed through the shadow of a crisis in two people's lives without having the least idea of what it was all about. What is it that the guy "has" to do? What was the lie? What should be A-okay and why is it not? Life does not seem very much like a soap opera most of the time. But it would if edited down to such moments.

Later I thought, "Well, they were giving thinking time—and it sure sounded like they needed to. They were talking it over, working it through. I hope they do it well."

Doing it well means more than spending time, of course. It means broad and adventurous thinking as well. Does the man really "have to?" What are his options? His "I have to" suggests that he or the woman might have reservations about the contemplated course of action. Maybe it might backfire. Have they looked more adventurously for less obvious options that buy time, risk less, exercise more subtlety?

Dealing with their situation well also means thinking clearly and deeply about it, paying attention to evidence, finding the essence. How do they know the man lied? Everything's okay, the man said on the phone. Might he honestly but mistakenly believe that everything *is* okay, or is he clearly misrepresenting the situation? Is

he the sort of person who would lie? Does he have a vested interest?

And dealing with their situation well means putting it all together, ending up with a vision of their circumstances, and a solid course of action. People on the park bench, don't flop around. Painful as the matter clearly is, keep your thinking organized as much as you can. Stake out your understandings, your evidence, your options. Make your best move.

Now why have I chosen to muse over this park bench episode about which we know so little? Paradoxically, not knowing much about the circumstances makes it easier to see the kinds of thinking questions that need to be asked—about action options, evidence, alternative interpretations, and so on. If we knew more, we would tend to get drawn into the particulars. It's so easy for our thinking to flow along familiar reflexive paths or sprawl into a bewildering delta of muddled ideas. In the midst of the soap opera, perhaps the trick is not to let yourself live it like one.

Watson: Holmes, you are a paradox!

Holmes: I have no doubt of it. But what particular convolution of my nature did you have in mind today?

Watson: I have been sitting here wondering when you would be done with the newspaper.

Holmes: And wherein the paradox?

Watson: Just this. That with a case at hand, you are the most superb exemplar of organized

thinking. You question, analyze, connect. You focus, explore, persist. Yet these days, with no client recently knocking at the door, you have become quite haphazard.

Holmes: And the newspaper is your evidence for this accusation?

Watson: Your manner of reading it, Holmes. First you read the front page. Then you turn to the middle. Not, I think, following any story so far as I could judge by your demeanor. Then back to the front. Then you toss the paper aside. Then seconds later you go back to it at another spot. There is my evidence.

Holmes: My dear Watson, you sound like me with this cataract of observations. But I challenge your interpretation. Instead, I might say that I was following a subtle train of thought. A hint on the front page of something afoot. A turn to the sports section to check on a matter that might be correlated. Back to the front to look for other leads. I put the paper aside to cogitate. I pick it back up to confirm my first observations.

Watson: You *could* say that. But frankly, Holmes, was this the course of events?

Holmes: You catch me in my vanity. No it was not. You are quite right. It was no more than idle flopping about. And I confess it.

Watson: How then to explain your double nature, Holmes, so organized and yet so haphazard?

Holmes: Hardly a puzzle there. I am organized when I need to be organized. When the game's afoot. When the stakes are high. When a puzzle stands before me. I know the necessity of it.

Watson: What necessity do you mean?

Holmes: The necessity to deploy one's mind in an organized fashion, in face of the powers of chaos. For the mind is not inherently a systematic organ. Stimuli come in. Ideas spark in our minds. Each event is an occasion to shoot off in some new direction. Each new direction leads to five other possible new directions. Putting this chaos in order is essential to dealing with any subtle problem.

Watson: It sounds to me as though this chaos could as well be creative as destructive. Could not this chaos, which you decry, yield insights by the very richness of its wandering?

Holmes: Indeed, Watson, sometimes. There certainly is a place for the free play of the mind, for following along threads of thought to other threads to see what may turn up.

Watson: Here you are likely to say, as you do regarding so many other matters about the art of thought, that it's a matter of good timing.

Holmes: You anticipate me, Watson. It is indeed a matter of good timing. The timing to give absolutely free fancy its place. Even a generous place. The wisdom not to overdo efforts to direct one's thoughts down narrow paths. But all that granted, the recognition that our thoughts tend to buzz around aimlessly like a dozen flies in a kitchen, unless we give them some direction.

Watson: And what form does this direction take, may I ask?

Holmes: In the broadest terms, I would say that it takes the form of cultivating in oneself the disposition to use what one knows about the art of thinking. For instance, the inclination to think clearly and deeply, searching out the essence, detecting the oddities, interpreting the significance. Or, for instance, the commitment to look beyond the obvious, to conceive of different viewpoints, different hypotheses.

Watson: Lucid as always, Holmes. So let us bring the matter back around. Why, with all this art at your disposal, do you toss the paper aside and pick it up again?

Holmes: Ah, Watson, I need a problem. I am like the soldier who is at a loss without a battle to fight. I am like the mother who hardly knows what to do when the children have left home. I am like the sailor when the wind has gone and the vessel floats becalmed. How can I organize my thinking when there is nothing to organize it *for?*

Watson: I should think that part of your art of thought would be to *find* challenges, not just to wait for them to come knocking at the door of 221B Baker Street. For instance, I recall that during previous droughts of clientele you have busied yourself with chemical experiments. Or you have refreshed yourself in one of your technical areas of expertise. Or even written a monograph.

Holmes: Watson, rightly do you upbraid me. Although there is nothing quite like the chase, I am surely not making good use of my time. Let us see whether I can conceive a project around which to organize my thinking. And to you, my dear friend, I hand over the newspaper. Your goal, at least, is achieved!

Building the Mind through Art

Art as an Occasion of Intelligence

"I can resist everything except temptation," wrote Oscar Wilde.[45] A real problem, when there are so many temptations to resist. And surely one of the most insidious is far from what we usually think of as temptation. It is the temptation of stereotypes.

For a case in point, consider looking at art. The temptation is to treat art as yielding up all to a glance, at least most of the time. The idea seems to be that the work of art is a kind of SWAT team of color, form, and line, put together to prove itself by its sensory assault on the viewer. The work asserts, the viewer beholds.

This notion is an insult to the intelligent eye. Although it has often been challenged, let us take a few moments to remind ourselves of the basic argument as formulated here. The stereotype of the passive viewer fails on two counts. First of all, looking at art demands what I called experiential intelligence. Recall that this means the intelligence of experience, what we gain from a rich range of knowledge and a multitude of encounters with diverse aspects of life. To the extent that we have considerable lived experience, know something of the past, speculate about the future, have some familiarity with source cultures, and a stock of general and par-

ticular knowledge of different kinds of art, we are readier to see what is there to be seen.

While seeing what art offers calls for experience of the world in general and some experience of the world of art, seeing what art offers also demands reflective intelligence. Experiential intelligence, remember, specializes in the quick take. It thrives on the expected. It honors the predictable over the adventurous, and the simple over the subtle. To bundle this in a quartet of quandaries, the output of our experiential intelligence can all too easily be "hasty, narrow, fuzzy, and sprawling."

By definition, reflective intelligence refers to the knowledge, skills, and attitudes that contribute to mental self-management. When we stand in front of a work of art, we need not respond willy-nilly. We can prompt our experiential intelligence, cajole it, aim it, redirect it, to arrive at more varied and deeper readings of the work before our eyes.

At the broadest level, this controlling role of reflective intelligence can be viewed as a matter of dispositions—the disposition to give looking time, to look broadly and adventurously, to look clearly and deeply, and to look in an organized fashion. These four dispositions counter one-on-one the four unfortunate dispositions that come part and

parcel with the power of experiential intelligence. When we put together the deliberative and managerial powers of reflective intelligence with the quick and flexible response mechanisms of experiential intelligence, then we truly have the intelligent eye.

Art is emblematic here. What is true of art holds for many other facets of life as well. Experiential intelligence working alone gets us by in familiar circumstances, where the quick take and the steady habit serve. But in the face of subtlety and novelty, those four intelligence traps of narrow, hasty, fuzzy, and sprawling thinking snap shut. We need the countervailing dispositions of reflective intelligence to make the most of experiential intelligence, to see better, to think better, and to act more wisely.

The Opportunity of Art

Now back to Oscar Wilde. The trouble with resisting temptations is that no sooner have you resisted one, than another is likely to pop up in its place. If we can resist the temptation of a stereotypical view of art, what next? Next is the lollipop wrapped in these pages, the idea that art is a tasty way to build better thinking. What a curious strategy!

Is it too good to be true? Should we dampen our hopes and sharpen our skepticism? A curmudgeon might well gripe as follows: "Lovely, I'm sure, all these experiences in front of paintings and sculptures. But what's so special about them as far as thinking is concerned? Why not build thinking through history or mathematics? And maybe better!"

The curmudgeon has at least part of a point. Any domain affords rich opportunities for the development of human thinking. But art offers something special. In several ways, looking at art is a particularly supportive platform for building thinking dispositions.

Take Figure 15's *L.D.*, for instance. *L.D.* is a 1937 drawing by the French artist Henri Matisse. Suppose you want to look at it, talk about it, and learn something from it. Something about art. And something about thinking. How might *L.D.* help you?

Sensory anchoring. Discussion is usually woven of words and memories—about baseball scores, presidential candidates, or yesterday's picnic, and, in classrooms, about the causes of the Civil War or the concept of a mole (chemistry or biology, take your choice). It's all too easy for attention to drift with nothing but a lattice of language and recollections to hang it on. And all too hard to check judgments directly. Here immediately a work of art is special. It or a reproduction can be physically present as you think and talk, providing an anchor for attention over a prolonged period of exploration. It's easy to spend a while with *L.D.*

Instant access. *L.D.*, or any other work, also helps out with "instant access." You can check something with a glance, point with a finger.

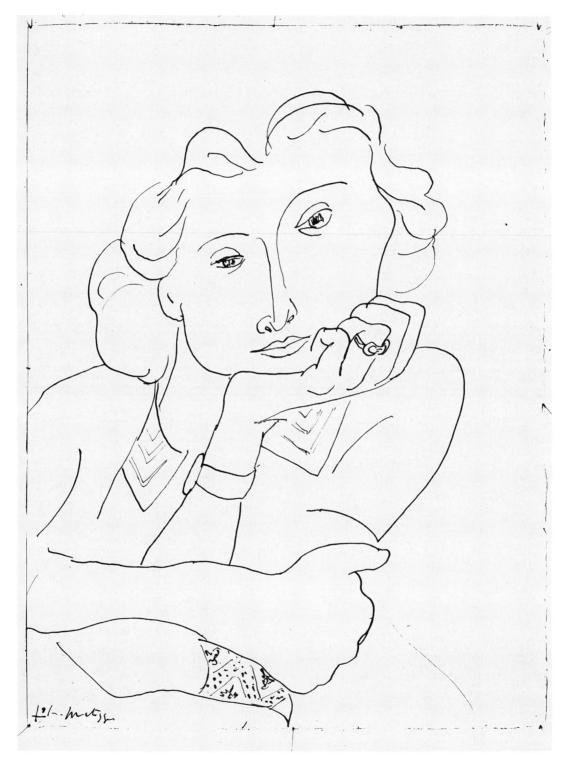

15. Henri Matisse, *L.D.,* 1937. Pen and india ink, 14 ¾ × 11 in.
© 1993 Succession H. Matisse/ARS, New York.

"Look how lost in her own world she seems," you say. "You know, the tilt of the head does a lot of that." You point to the tilt. "Look at the line of the eyebrows." You point to them. "Imagine that her head wasn't tilted, her eyebrows level. She'd look a lot more alert instead of lost in thought."

If instant access seems too obvious to mention, remember how different discussing last night's sitcom or short story is. The sitcom lies in the past, the short story sprawls across several pages and several minutes of reading. You have to check judgments by memory or riffling pages. *L.D.* is here and now.

Personal engagement. Works of art invite and welcome sustained involvement. Perhaps you resonate sympathetically to the pensive *L.D.*, recalling bemused moments of your own. Or perhaps it makes you furious: "The daydreaming of this pretty woman reflects the typical male artist's treatment of women as pretty things." This is personal engagement, too, just as visceral although far from what Matisse had in mind. While there will always be some neutral responses, by their very nature, works of art are likely to stimulate one kind of spasm or another.

Dispositional atmosphere. All this plays well into the dispositional character of thinking. I have emphasized that thinking is a passionate enterprise. Giving thinking time, thinking broadly and adventurously, and so on, are uses of the mind that call for concern and commitment, spirit and persistence. In an atmosphere of heightened affect, the dispositional side of thinking seems more at home. For instance, L.D. herself might be giving thinking time—musing about an old lover or a new one, or recalling how on her eighth birthday she flew a kite so high it almost disappeared.

Wide-spectrum cognition. Building thinking around a work of art guarantees the involvement of multiple sensory modalities. *L.D.* puts to work your pictorial and spatial perception on the one hand and more verbal analytical kinds of thinking on the other. It encompasses what Rudolf Arnheim calls visual thinking as well as other modes of cognition.[46] It addresses the range of symbol systems Nelson Goodman writes of in his *Languages of Art.* All this suits well the character of real-world thinking. By and large, we reason about things we see and on which we can lay our hands, into which we can project ourselves physically and emotionally—whether to buy this watch, accept that job, dare a ride on the carnival Tilt-a-Whirl. Central to experiential intelligence is its experiential character, its roots in our sensory world of actions and reactions. Real-world thinking is almost always wide spectrum in character, rarely just a play of words or symbols. So with art: In thinking about Matisse's *L.D.*, we *meet* L.D. However they

grow and branch, our thoughts cling around the trellis of that perceptual reality.

Multiconnectedness. What is *L.D.* in the end? A study of grace in line. A symbol of male artists' reduction of women to pretty things. An intense evocation of day dreaming. An oddly distorted image (why is *L.D.*'s forehead so short, her cheekbone on the right so protuberant?). An exercise in weight and balance (notice the architecture of *L.D.*'s arms, hands, and chin, creating a tilted structure that, like the Leaning Tower of Pisa, nonetheless stands up). And many other things too. In other words, there is no "in the end." Art tends to be multiconnected. We can find links with many things—social issues, aesthetic concerns, trends of the times, personal commitments, even science and mathematics sometimes. Art is generally richly connected culturally and historically. The connections range from ones easily accessible to most human beings to arcane references only penetrable by a scholar of the place and time of origin. The multiconnectedness of art creates an opportunity to bridge thinking dispositions across to diverse other contexts explored in tandem with the work of art.

As Oscar Wilde reminds us, temptation is hard to resist. But thankfully not all temptations need to be resisted. The above catalogue makes it clear that many of the temptations of cultivating thinking through the arts are more than just lures—they are good reasons for doing so.

The Challenge of Transfer

L.D. today, smarter decision making tomorrow. Art builds better thinking, right?

That depends. We cannot expect even thoughtful experiences of looking at art to spill over and make our thinking better elsewhere unless we work hard to make it happen. Here is why.

It all turns on one of psychology's most central ideas about human learning, the concept of transfer. By transfer is meant the impact of learning in one context on performance in other significantly different contexts. For example, you learn to drive a car. Later, moving your household, you rent a small truck and find that you can drive it fairly well. That's transfer. Or, for example, you enjoy playing chess. Later, entering a local political race, you find that principles of chess, like "strive for control of the center," help you in your strategizing. That's transfer as well. Or you study French in college. Later, planning a trip to Italy, you study Italian and find that some things you learned in studying French spill over and help you—some specific vocabulary but also a heightened awareness of syntax, certain tricks for memorizing, and the confidence that you can handle the learning of a language. That's transfer too.

The catch is this. Considerable research tracing back to the beginning of the twentieth century argues that, very often, the transfer we want simply does not occur. Learners do not

carry over what they learn in one context to other contexts. For example, while almost anyone would make the car-to-truck transfer mentioned above, the chess-to-politics transfer is much less likely. After all, sitting behind the wheel of a truck reminds you of all your car-driving skills, which apply well to the truck context. But politics does not necessarily remind you of chess. It's easy to miss useful connections.

So bleak a picture has been presented by the long history of research on transfer that some educational psychologists have come close to concluding that transfer is a lost cause: Except in circumstances quite similar to one another (the car-to-truck case), we cannot expect much transfer. Each skill, strategy, fact, attitude, and concept has to be learned in its own context.

If this were true, it would be bad news for the enterprise of building thinking through the arts, or in any other general way. It would say that people have to learn to think better situation by situation. The hope of developing generally helpful thinking dispositions, or anything else helpful over a diversity of circumstances, would be slim.

But the prospects of wide and fruitful transfer are not as grim as they might seem from the story so far. While many studies of transfer have yielded negative results, a few have shown positive ones. It's critical to understand what factors make for success when it happens. My colleague Gavriel Salomon and I have proposed a model accounting for both the successes and the failures.[47] According to this model, transfer is a finicky phenomenon. Transfer has generally not occurred because the conditions needed for transfer were usually not present.

However, the conditions for transfer can easily be engineered into instructional situations. We will get transfer when we teach for transfer. In particular, transfer depends on building certain conditions into the instructional experience. According to the view of Salomon and Perkins, there are two alternative approaches:

1. **Abundant and diverse practice.** Well-mastered skills are more likely to stand up in new contexts. And diverse practice prepares the mind for a variety of future applications. Unfortunately, in most school settings, skills and knowledge are underpracticed, or practiced only in a narrow range of circumstances. Or . . .

2. **Reflective awareness of principles and deliberate mindful connection making.** These encourage seeing the common principles that bridge disparate contexts. Unfortunately, in most school settings, skills and knowledge are learned in a rote rather than a

reflective way, with little attention to mindful connection making.

Of course, both of these approaches can be used at the same time. Salomon and I call the first of these the "low road" to transfer, because it depends on automatic triggering of prior learnings. We call the second the "high road" to transfer, because it depends on mindful reflection and active connection making. The moral: If we want far-reaching transfer, we can have it. But we have to build in abundant and diverse practice for the low road, or reflective connection making for the high road, or, better yet, both.

What does this mean concretely? Suppose you are a teacher. What can you do around Matisse's *L.D.* to teach for transfer? Here are some possibilities:

- Make Matisse's *L.D.* part of a much larger program. Over a number of weeks, take up varied works of art representing different cultures and periods. Look at them all with attention to the four dispositions. This exercises the "low road," plenty of diverse experience. But what kinds of experiences? Read on. . . .

- Welcome personal connections. What are your experiences of bemusement? How akin do you feel to *L.D.?* This makes connections to everyday life.

- Provoke reflection around those experiences. What do you think of daydreaming? Does it have a function? Is it a waste of time? This is a piece of the "high road," abstract reflective thinking.

- Raise the feminist issue if it does not come up. It connects Matisse's work to other dimensions of life. More high road reflective thinking.

- And throughout all this, promote good dispositions for looking and for thinking alike— giving looking and thinking time, making looking and thinking broad and adventurous, clear and deep, and organized. Explicit recognition of these dispositions takes the high road, dealing in articulate abstractions that help us to connect across different contexts of thinking.

Many teachers and some students might be alarmed at all this. Does it not reach too far beyond the work of art itself? Are we not losing sight of *L.D.* in its specificity? It's all a question of balance. No one is suggesting we spend all our *L.D.* time thinking about other things altogether. But if the rectangular boundaries of the drawing itself are never violated, the dispositions cultivated in looking at the work are likely not to spill over and inform learners' abilities and attitudes more widely.

Besides, in large part, works of art resist being kept within their frames. They reach out by design. We have to be ready to reach with them to partake of what they offer.

Art and the Wide World

The world of art as youngsters usually meet it is a narrow one. Art means studio art and often the most trivial versions of it—pumpkin cutouts for Halloween, turkey cutouts for Thanksgiving, the perennial parade. Of course, this cutout mentality cuts out most of the richness in the art.

Part of making art a more meaningful pursuit and connecting it to a wider world consists in making the world of art itself wider. This concern sounds clearly in the Getty Center for Education in the Arts' emphasis on discipline-based art education. The Center has advocated art studies as a distinct and worthwhile discipline that should take its place alongside the other disciplines taught in today's schools. Moreover, the Center has pressed the case for a multifaceted approach that recognizes diverse perspectives on art. As described by Elliot Eisner and by Stephen Dobbs, a well-rounded program includes attention to art production, art criticism, art history, and aesthetics (issues of value and interpretation).[48]

While these chapters have emphasized art criticism, clearly all four of the Getty themes feed one another. Moreover, all four invite attention to the thinking dispositions so central to the

good use of one's mind. In the studio as well as in front of *L.D.*, one can give thinking time, make thinking broad and adventurous, clear and deep, and organized. In understanding historical perspectives on art and struggling with deep issues of aesthetics, we need to exercise persistent, adventurous, deep, and organized thinking. All in all, the four pillars of discipline-based art education define a spacious atrium where thinking dispositions can thrive.

However rich the wide world of the arts, the wider world beyond the arts issues even more of an invitation to powerful dispositions of thinking. From choosing a site for a holiday to selecting a school, from puzzling over a math problem to pondering for whom to vote, from programming a computer to planning a political campaign, circumstances call for thoughtfulness. While our routine habits of thinking may satisfy our needs 90% of the time, we need the 10% solution, the thinking dispositions of reflective intelligence to manage the best deployment of our experiential intelligence.

Nowhere is this message more called for than in educational reform. After all, schools, more than any other single element of society, have the potential to cultivate thoughtfulness and contribute more critical and creative graduates to the future. In my recent *Smart Schools,* I argue that today we have an understanding of teaching, learning, and the nature of intelligence ample to transform education into a

much more thinking-centered process than it usually is.[49] We can organize education effectively for the enhancement of understanding and thinking. Central to such a vision is the cultivation of key thinking dispositions.

In all this, art has a distinctive role to play. The liberal borders of art help us to carry good thinking dispositions nurtured in the context of art to the wider world. Art is an extrovert. Art connects because artists make it connect, because artists strive to express not just the anatomy of bodies but the anatomy of the human condition and of the universe that impinges upon it. If most disciplines dig moats, art builds bridges.

References

1. S. McKinnon, "Tanimbar Boats," in *Islands and Ancestors: Indigenous Styles of Southeast Asia*, eds. J. P. Barbier and D. Newton (Munich, Germany: Prestel-Verlag, 1988), 152–169, quotation from p. 155.

2. See National Assessment of Educational Progress, *Reading, Thinking, and Writing* (Princeton, NJ: Educational Testing Service, 1981).

3. This case has recently been argued by D. N. Perkins, E. Jay, and S. Tishman, "Beyond Abilities: A Dispositional Theory of Thinking," *The Merrill-Palmer Quarterly*, 39(1) (1993): 1–21. Others who advocate the importance of dispositions include: J. Baron, *Rationality and Intelligence* (New York: Cambridge University Press, 1985) and R. H. Ennis, "A Taxonomy of Critical Thinking Dispositions and Abilities," in *Teaching Thinking Skills: Theory and Practice*, eds. J. B. Baron and R. S. Sternberg (New York: W. H. Freeman, 1986), 9–26.

4. D. N. Perkins, *Smart Schools: From Training Memories to Educating Minds* (New York: Free Press, 1992).

5. P. Yenawine, *How to Look at Modern Art* (New York: Harry N. Abrams, 1991), 25.

6. R. Arnheim, *Visual Thinking* (Berkeley: University of California Press, 1969). E. W. Eisner, *Cognition and Curriculum: A Basis for Deciding What to Teach* (New York: Longman, 1982).

7. N. Z. Berliner, *Chinese Folk Art: The Small Skills of Carving Insects* (Boston: Little, Brown, 1986), 88.

8. The early history of IQ can be found in S. J. Gould, *The Mismeasure of Man* (New York: W. W. Norton, 1981).

9. Ibid., 160.

10. H. Gardner, *Frames of Mind* (New York: Basic Books, 1983). J. Horn, "Models of Intelligence," in *Intelligence: Measurement, Theory, and Public Policy*, ed. R. Linn (Chicago: University of Illinois Press, 1989), 29–73.

11. R. J. Sternberg, *Beyond I.Q.: A Triarchic Theory of Human Intelligence* (New York: Cambridge University Press, 1985).

12. S. J. Ceci, *On Intelligence . . . More or Less: A Bioecological Treatise on Intellectual Development* (Englewood Cliffs, NJ: Prentice-Hall, 1990).

13. See e.g.: A. R. Jensen, *Bias in Mental Testing* (New York: Free Press, 1980). A. R. Jensen, "Test Validity: g versus the specificity doctrine," *Journal of Social and Biological Structures*, 7 (1984): 93–118. A. R. Jensen, "g: Artifact or Reality?" *Journal of Vocational Behavior*, 29 (1986): 301–331.

14. Gardner, op. cit.

15. See e.g.: W. C. Chase and H. A. Simon, "Perception in Chess," *Cognitive Psychology*, 4 (1973): 55–81. A. D. de Groot, *Thought and Choice in Chess* (The Hague: Mouton, 1965).

16. See Ceci, op. cit.

17. Sternberg, op. cit.

18. J. Baron, *Rationality and Intelligence* (New York: Cambridge University Press, 1985). J. Baron, *Thinking and Deciding* (New York: Cambridge University Press, 1988).

19. See e.g.: R. Nickerson, D. N. Perkins, and E. Smith, *The Teaching of Thinking* (Hillsdale, NJ: Lawrence Erlbaum, 1985). D. N. Perkins, E. Jay, and S. Tishman, op. cit. D. N. Perkins and G. Salomon, "Are Cognitive Skills Context Bound?" *Educational Researcher,* 18 (1), (1989): 16–25. R. J. Swartz and D. N. Perkins, *Teaching Thinking: Issues and Approaches* (Pacific Grove, CA: Midwest Publications, 1989).

20. M. F. Friedman, "Introduction and Interviews with Claes Oldenberg," in *Oldenburg: Six Themes* (exhibition catalogue) (Minneapolis: Walker Art Center, 1975), 63.

21. A previous volume in this series addresses aspects of development: H. Gardner, *Art Education and Human Development* (Los Angeles: Getty Center for Education in the Arts, 1990). Other useful sources are: E. Winner, *Invented Worlds: The Psychology of the Arts* (Cambridge, MA: Harvard University Press, 1982). M. J. Parsons, *How We Understand Art: A Cognitive Developmental Account of Aesthetic Experience* (New York: Cambridge University Press, 1987).

22. M. Kearns, *Käthe Kollwitz: Woman and Artist* (Old Westbury, NY: Feminist Press, 1976), 169.

23. E. Prelinger, *Käthe Kollwitz* (Washington, D.C.: National Gallery of Art, and New Haven, CT: Yale University Press, 1992), 63.

24. M. C. Klein and H. A. Klein, *Käthe Kollwitz: Life in Art* (New York: Holt, Rinehart and Winston, 1972), 81.

25. N. A. Goodman, *Languages of Art* (Indianapolis: Hackett, 1976).

26. William Wordsworth, *The Thorn,* 1798.

27. On what awaits versus what hides: In much the same spirit, some of my earlier research emphasized raising students' awareness of "aesthetic effects," features that have high aesthetic payoff in contrast with those sometimes focused upon in art historical or art critical analysis. See: D. N. Perkins, "Invisible Art," *Art Education,* 36(2) (1983): 39–41. D. N. Perkins, "Art as an Occasion of Intelligence," *Educational Leadership,* 45(4) (1988): 36–43.

28. K. Clark, *Looking at Pictures* (New York: Holt, Rinehart and Winston, 1960).

29. Ibid., 31–32.

30. T. Wolfe, *The Painted Word* (New York: Bantam Books, 1976), 86.

31. Clark, op. cit., 15.

32. Perkins, Jay, and Tishman, op. cit.

33. Clark, op. cit., 22.

34. For a fuller examination of the role of words in the perception of art, see D. N. Perkins, "Talk about Art," *Journal of Aesthetic Education,* 11(2) (1977): 87–116.

35. This story was told to me by a South African colleague, Muzi Sibisi, in connection with a collaborative curriculum development project concerning the teaching of thinking. His parents told it to him.

36. My colleagues Shari Tishman, Eileen Jay, and Heidi Goodrich have been actively developing the

notion of teaching through enculturation in collaboration with me. See S. Tishman, E. Jay, and D. N. Perkins, "Thinking Dispositions: From Transmission to Enculturation," *Theory Into Practice*, 32(3) (1993): 147–153.

37. The work of John Muafangejo is discussed in G. Younge, *Art of the South African Townships* (New York: Rizzoli, 1988), 90–93.

38. This is an adaptation of a favorite story of Robert Sternberg, who often uses it in presentations.

39. H. D. Smith, *Hokusai: One Hundred Views of Mt. Fuji* (New York: George Braziller, 1988).

40. A. C. Doyle, "Silver Blaze," in *The Complete Sherlock Holmes* (Garden City, NY: Doubleday, 1960; original publication 1894).

41. Wolfe, op. cit., 4.

42. Yenawine, op. cit., 22.

43. E. B. Feldman, *Varieties of Visual Experience: Art as Image and Idea (Revised and Enlarged Edition)* (New York: Harry N. Abrams, n.d.). On "the critical performance" see pp. 634–661.

44. H. S. Broudy, *The Role of Imagery in Learning* (Los Angeles: Getty Center for Education in the Arts, 1987). Regarding aesthetic scanning in general, see p. 50. Regarding details of the scheme developed by Broudy and Silverman, see the Appendix, pp. 52–55.

For a fuller albeit earlier exposition of Broudy's ideas, see H. S. Broudy, *Enlightened Cherishing: An Essay on Aesthetic Education* (Urbana: University of Illinois Press, 1972).

45. From O. Wilde, *A Woman of No Importance*, Act 1 (1983 ed.).

46. Arnheim, op. cit.

47. D. N. Perkins and G. Salomon, "Transfer and Teaching Thinking" in *Thinking: The Second International Conference*, eds. D. N. Perkins, J. Lochhead, and J. Bishop (Hillsdale, NJ: Lawrence Erlbaum, 1987), 285–303. D. N. Perkins and G. Salomon, "Teaching for Transfer," *Educational Leadership*, 46(1) (1988): 22–32. G. Salomon and D. N. Perkins, "Rocky Roads to Transfer: Rethinking Mechanisms of a Neglected Phenomenon," *Educational Psychologist*, 24(2) (1989): 113–142. For a practical classroom guide to teaching for transfer, see R. Fogerty, D. N. Perkins, and J. Barell, *How to Teach for Transfer* (Palatine, IL: Skylight Publishing, 1991).

48. See S. M. Dobbs, *The DBAE Handbook: An Overview of Discipline-Based Art Education* (Santa Monica, CA: Getty Center for Education in the Arts, 1992). E. W. Eisner, *The Role of Discipline-Based Art Education in America's Schools* (Los Angeles: Getty Center for Education in the Arts, 1988).

49. D. N. Perkins, *Smart Schools: From Training Memories to Educating Minds* (New York: Free Press, 1992).

David N. Perkins

David Perkins received his Ph.D. in mathematics and artificial intelligence from the Massachusetts Institute of Technology in 1970. He was a founding member of Project Zero at the Harvard Graduate School of Education. The project, initially concerned with the psychology and philosophy of education in the arts, now encompasses cognitive development and cognitive skills in both humanistic and scientific domains.

Since 1971, Dr. Perkins has served as co-director of Project Zero. He has conducted long-term programs of research and development in the areas of teaching and learning for understanding, creativity, problem solving, and reasoning in the arts, sciences, and everyday life. He has helped develop materials to assist teachers in integrating the teaching of thinking with subject-matter instruction; a telecourse with the same aim; a course to teach thinking skills for use in Venezuela and the United States; a program to build thinking dispositions and another to build mathematics understanding for use in disadvantaged South African settings; and other programs and materials.

His research on creativity resulted in *The Mind's Best Work* (1981). Among his other books are *The Teaching of Thinking* (with Raymond Nickerson and Edward Smith, 1985), *Knowledge as Design* (1986), *Teaching Thinking: Issues and Approaches* (with Robert Swartz, 1989), and *Smart Schools: From Training Memories to Educating Minds* (1992).

Managing Editor: Kathy Talley-Jones
Designer: Eileen Delson
Cover Illustration: Roland Young
Production Coordinator: Martha Drury
Illustration Coordinators: Diane Downs, Adrienne Lee
Manuscript Preparation: Diane Downs, Madeleine Coulombe, Adrienne Lee
Copy Editor: Anita Keys